Baltica
Coloring book inspired by Latvian folk art

Baltica Volume I, Fourth edition, Copyright © 2025 Alice Koko. All rights reserved.

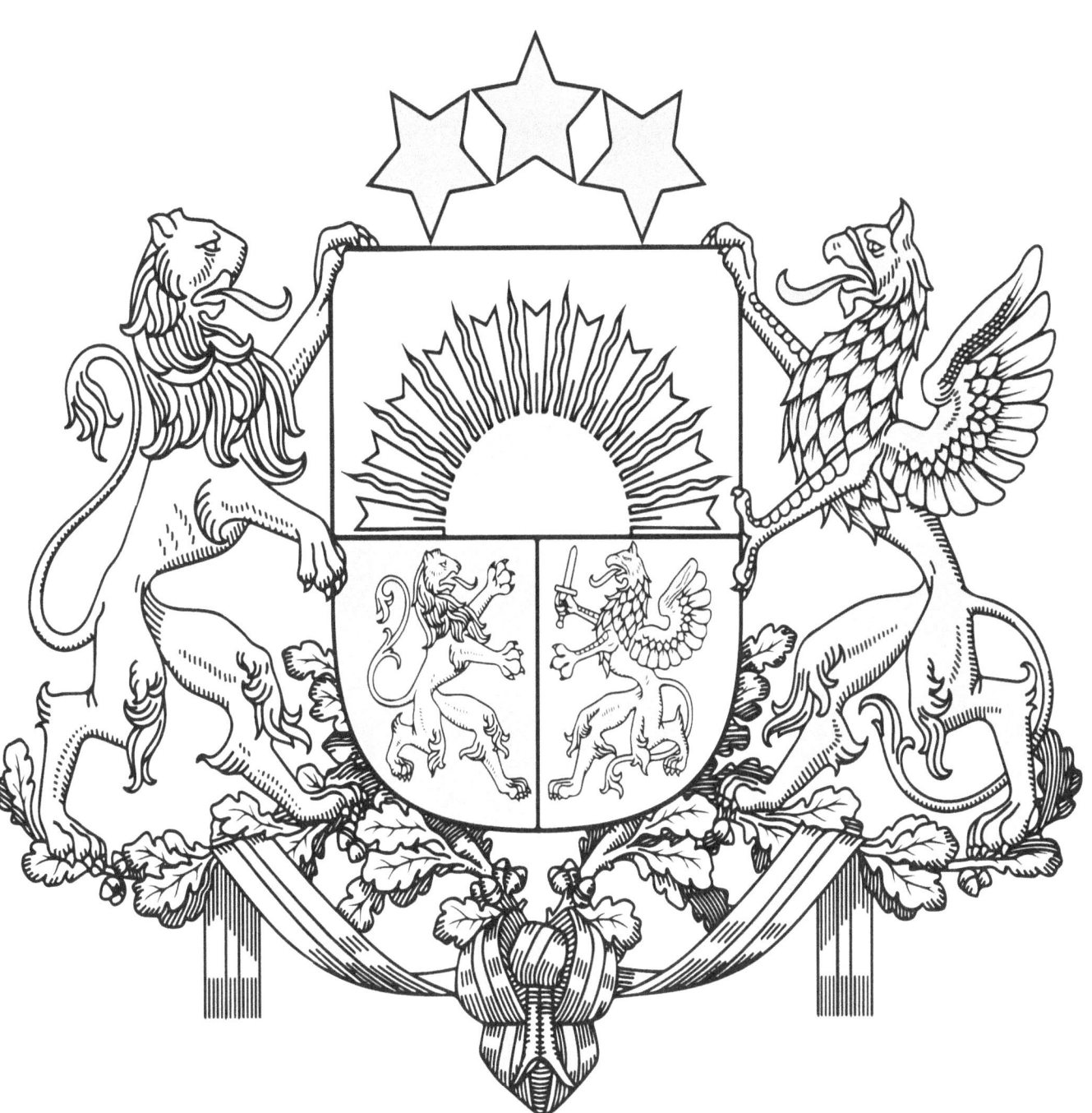

Latvia is a Baltic state in northern Europe; it is bordered by Estonia to the north, Lithuania to the south, Russia to the east and Belarus to the southeast, coastline of the Baltic Sea as well maritime border to the west alongside Sweden. It's landscape is marked by wide beaches on the shores of Baltic Sea that stretches 500 km and dense, sprawling forests that cover more than half of the country. It is situated on a trading crossroads and has served as a bridge between Western Europe and Russia for centuries. Riga is the capital of Latvia. Riga's Old town is a UNESCO heritage site as well Art Nouveau capital of the world. It is considered the "Paris of the North."
Latvia is renowned for its masterful craftsmanship and beautiful folk art in textiles, embroidery and knitwear. Handicraft traditions are honored and passed on for generations. Here's a little glimpse into the beauty of the Latvian folk art.
Enjoy!

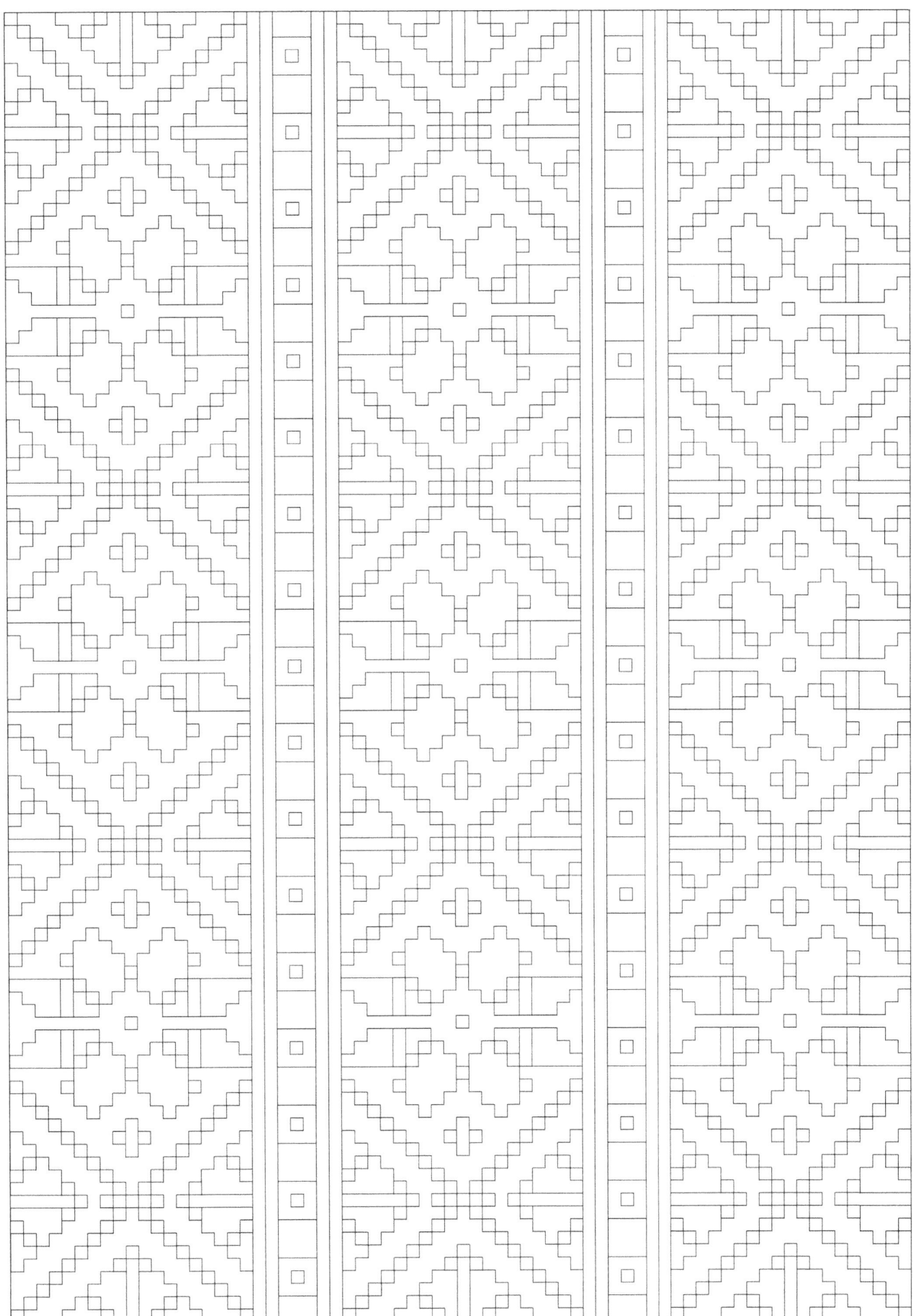

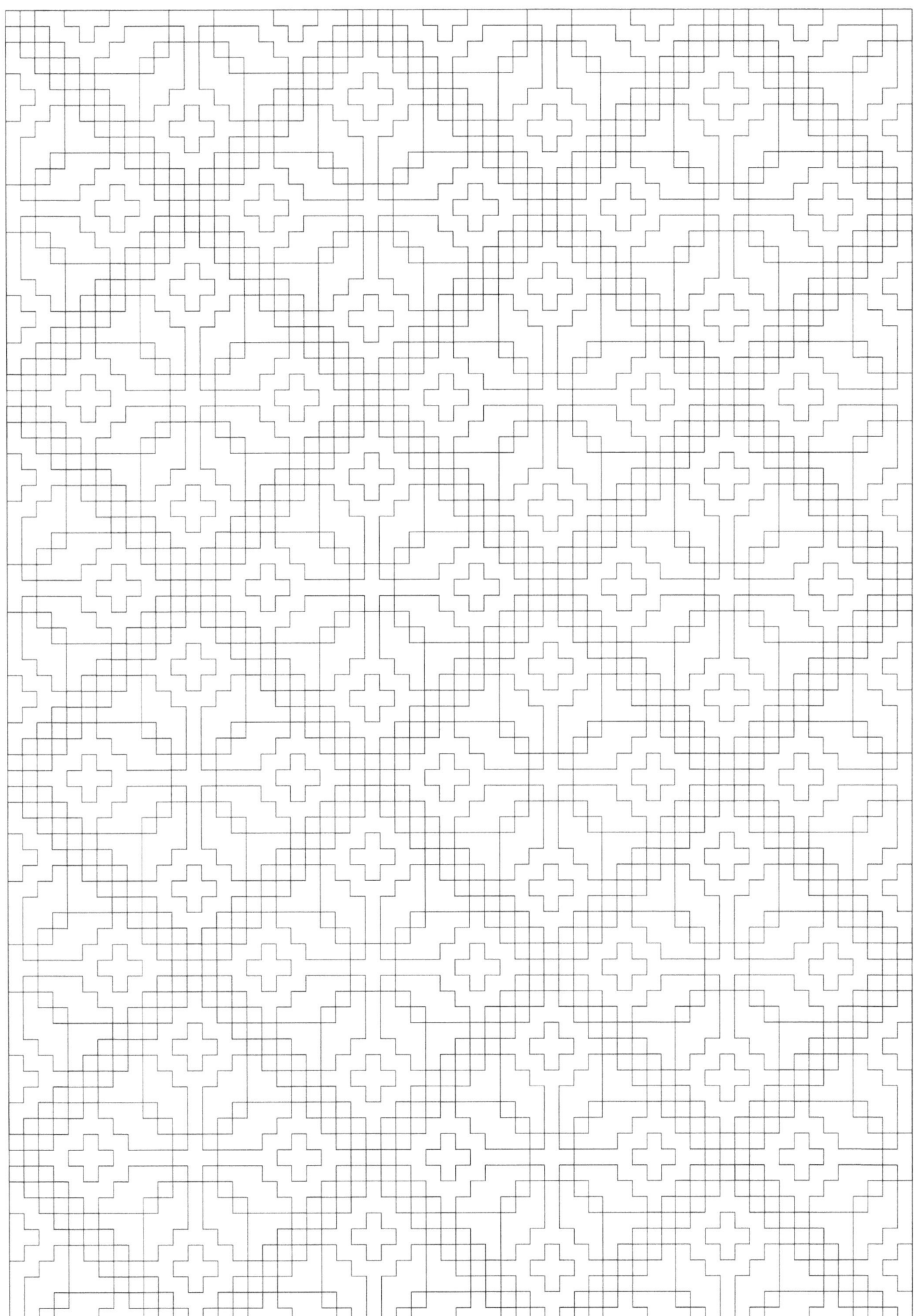

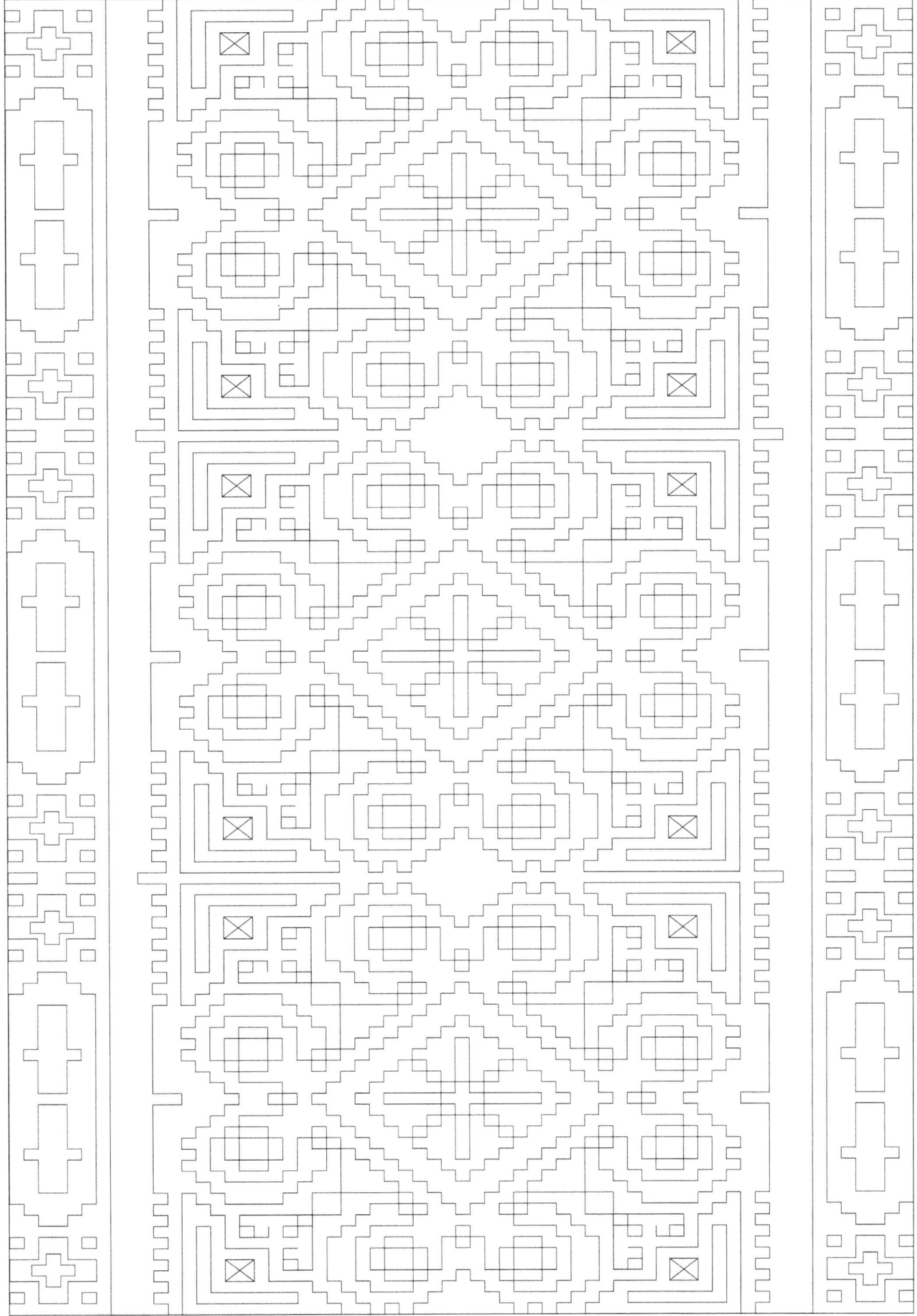

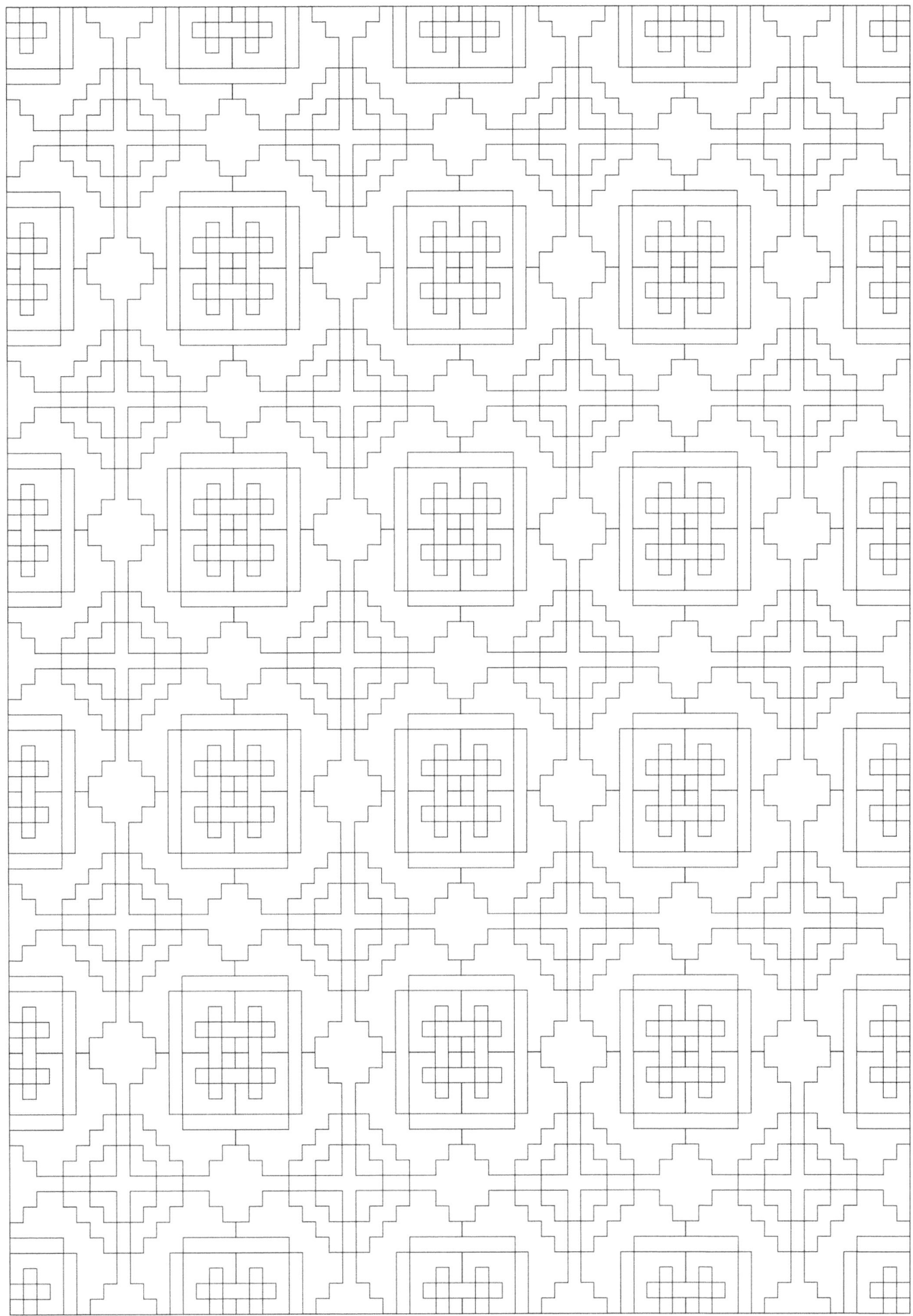

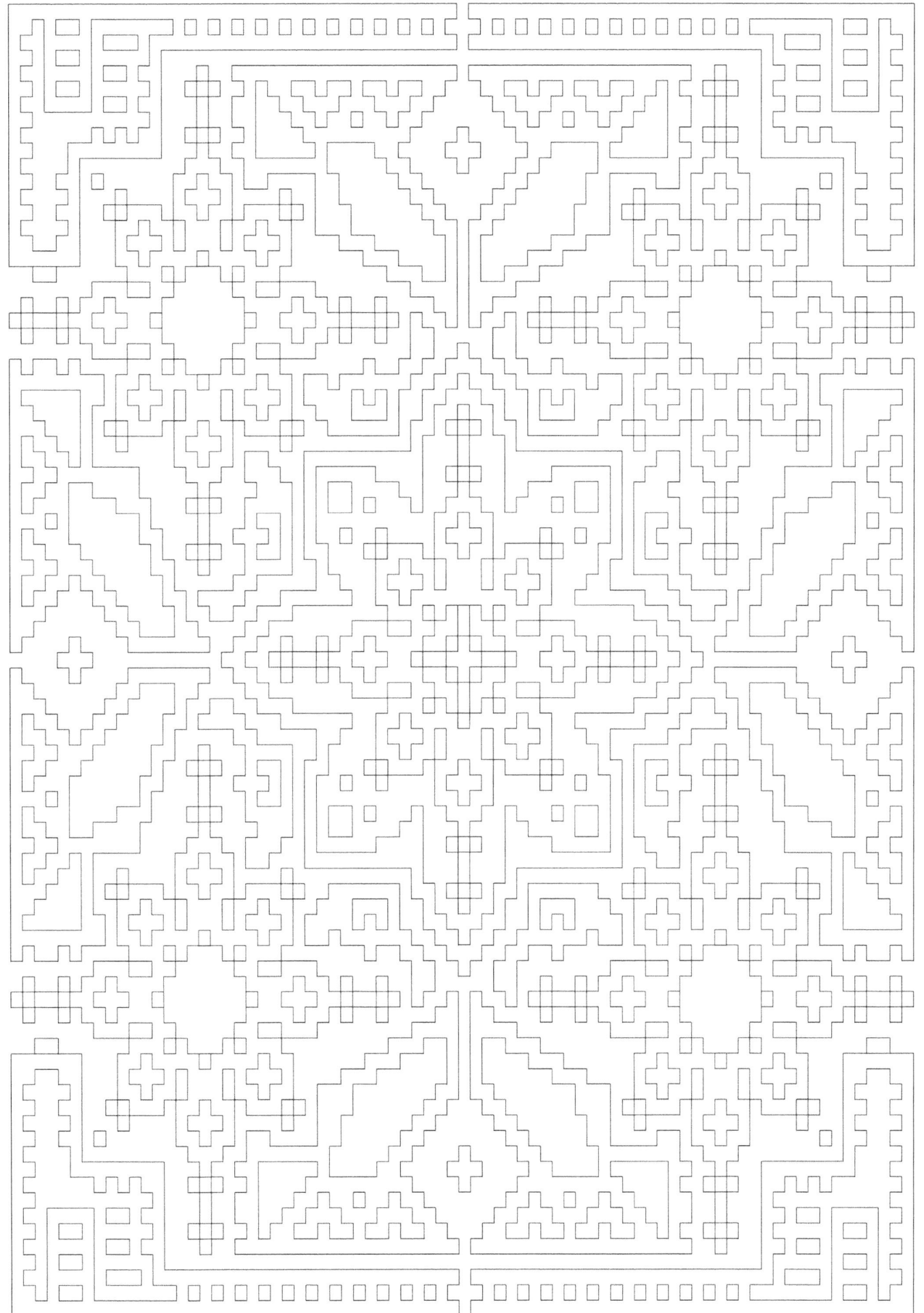

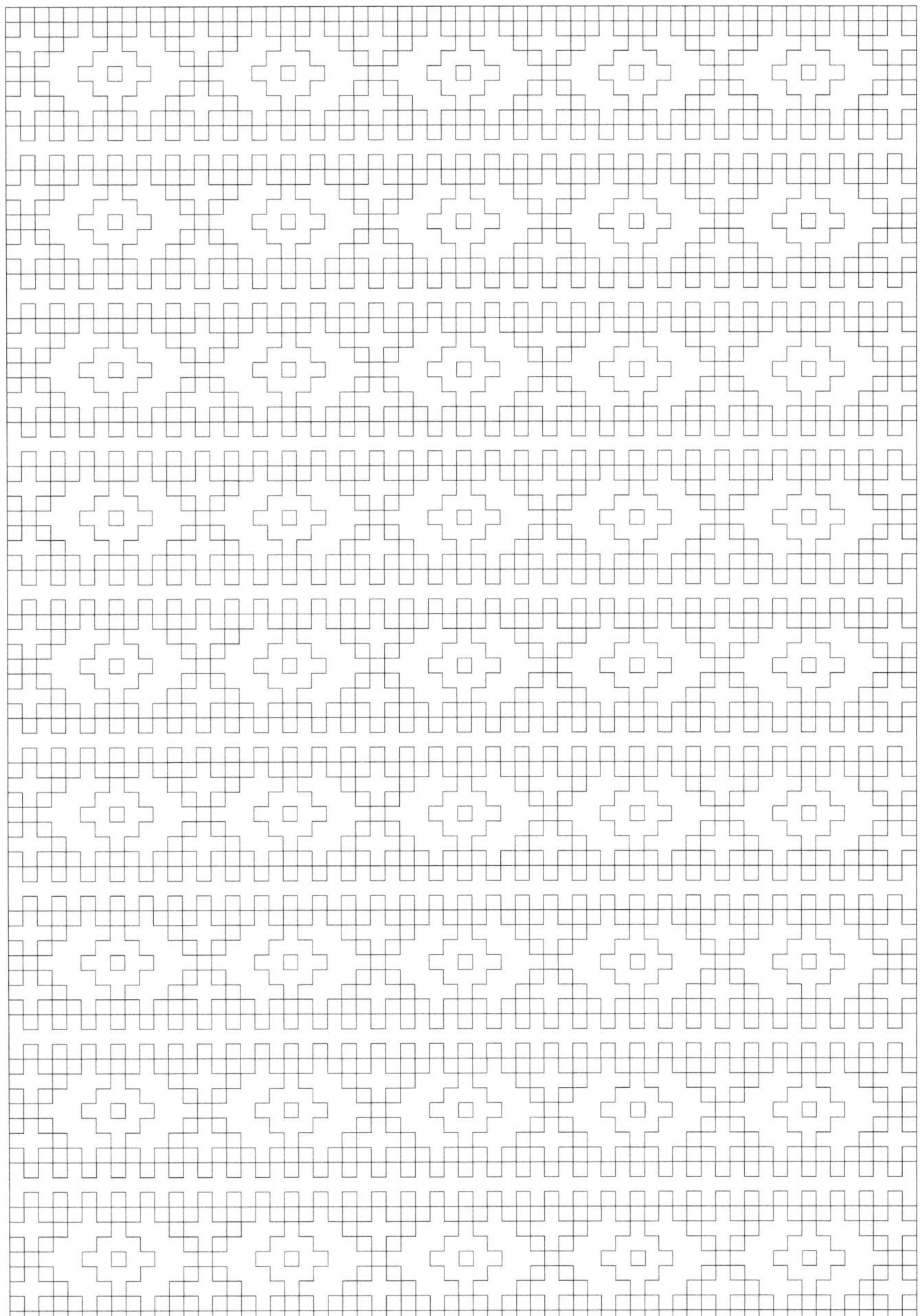

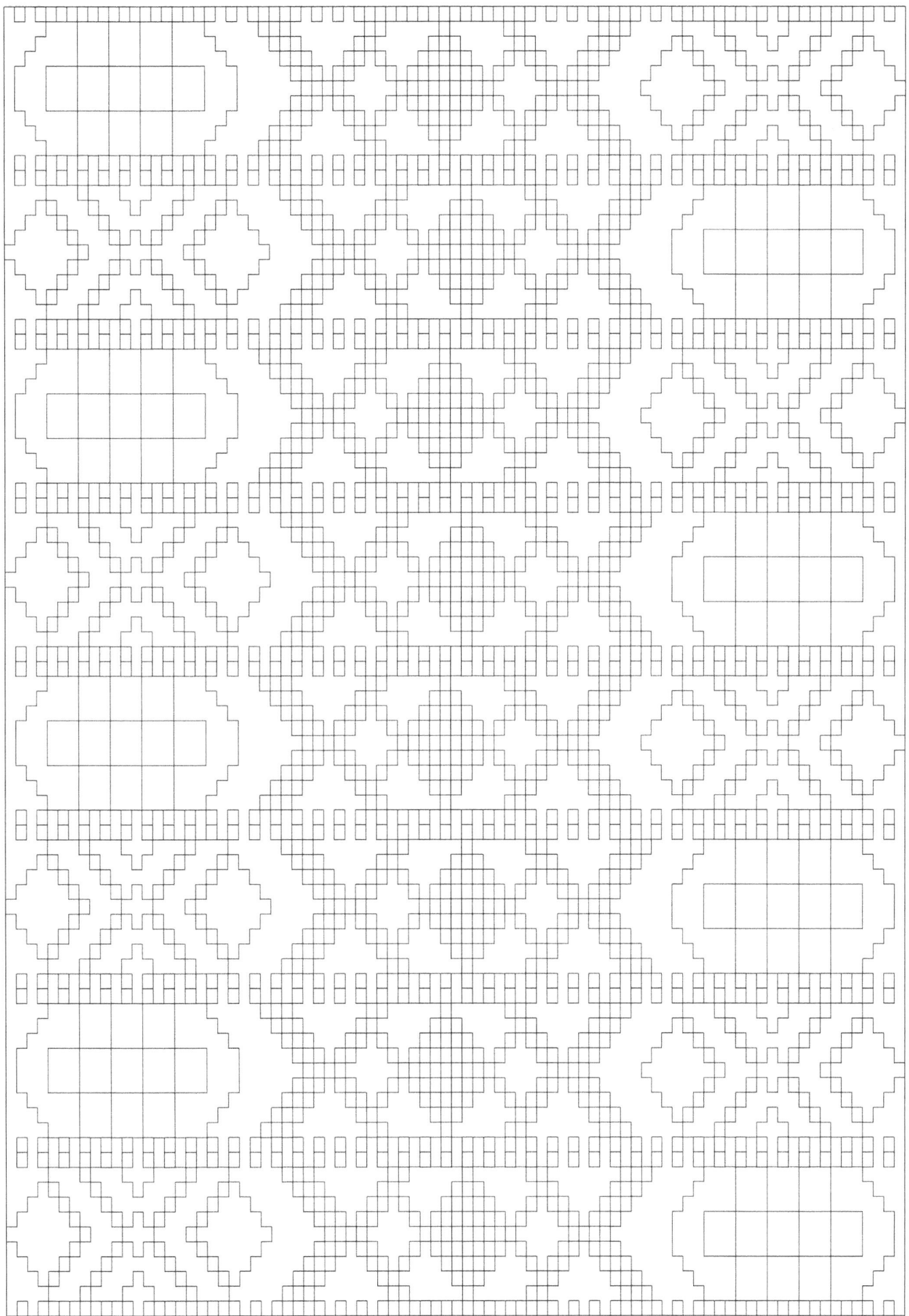

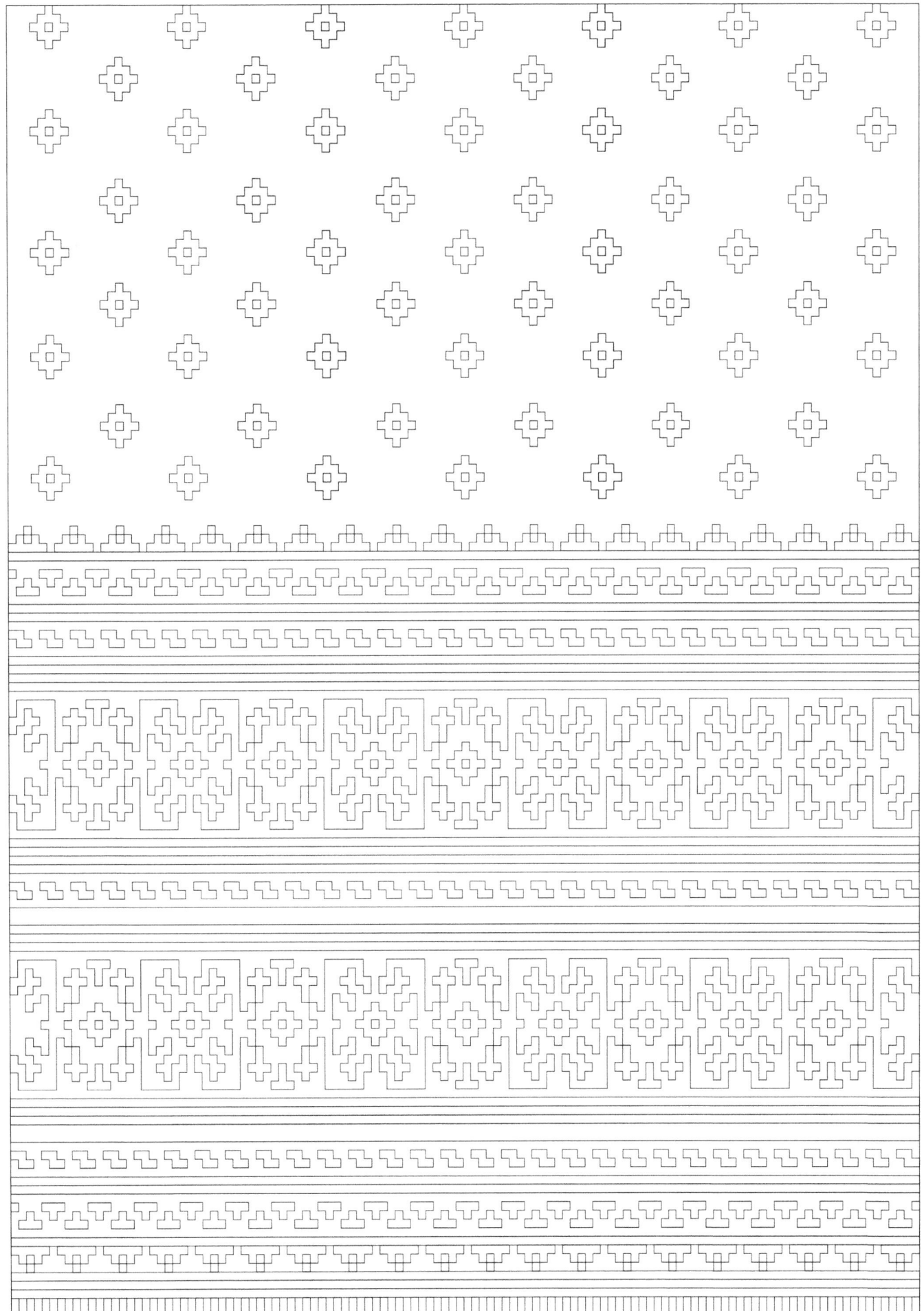

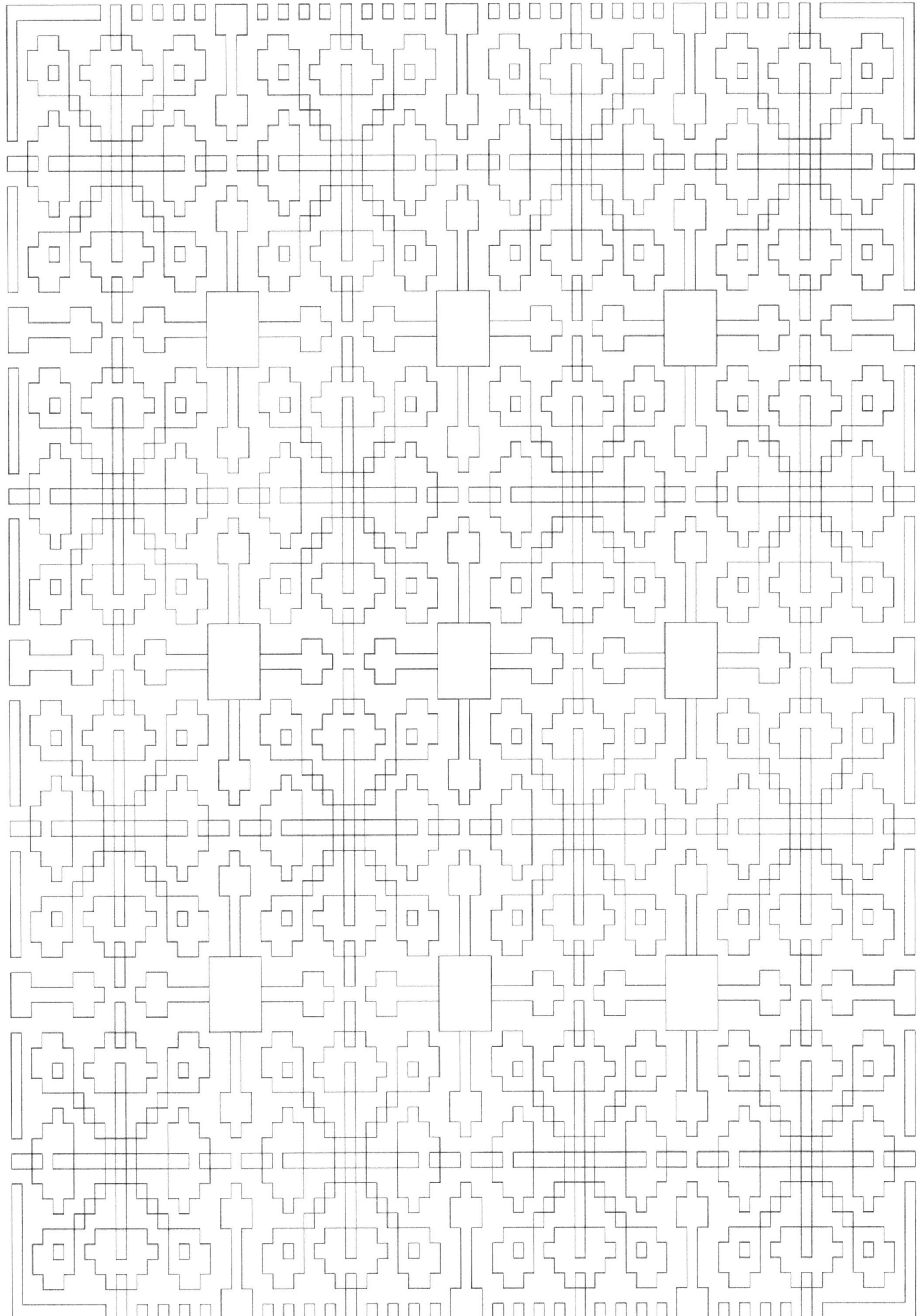

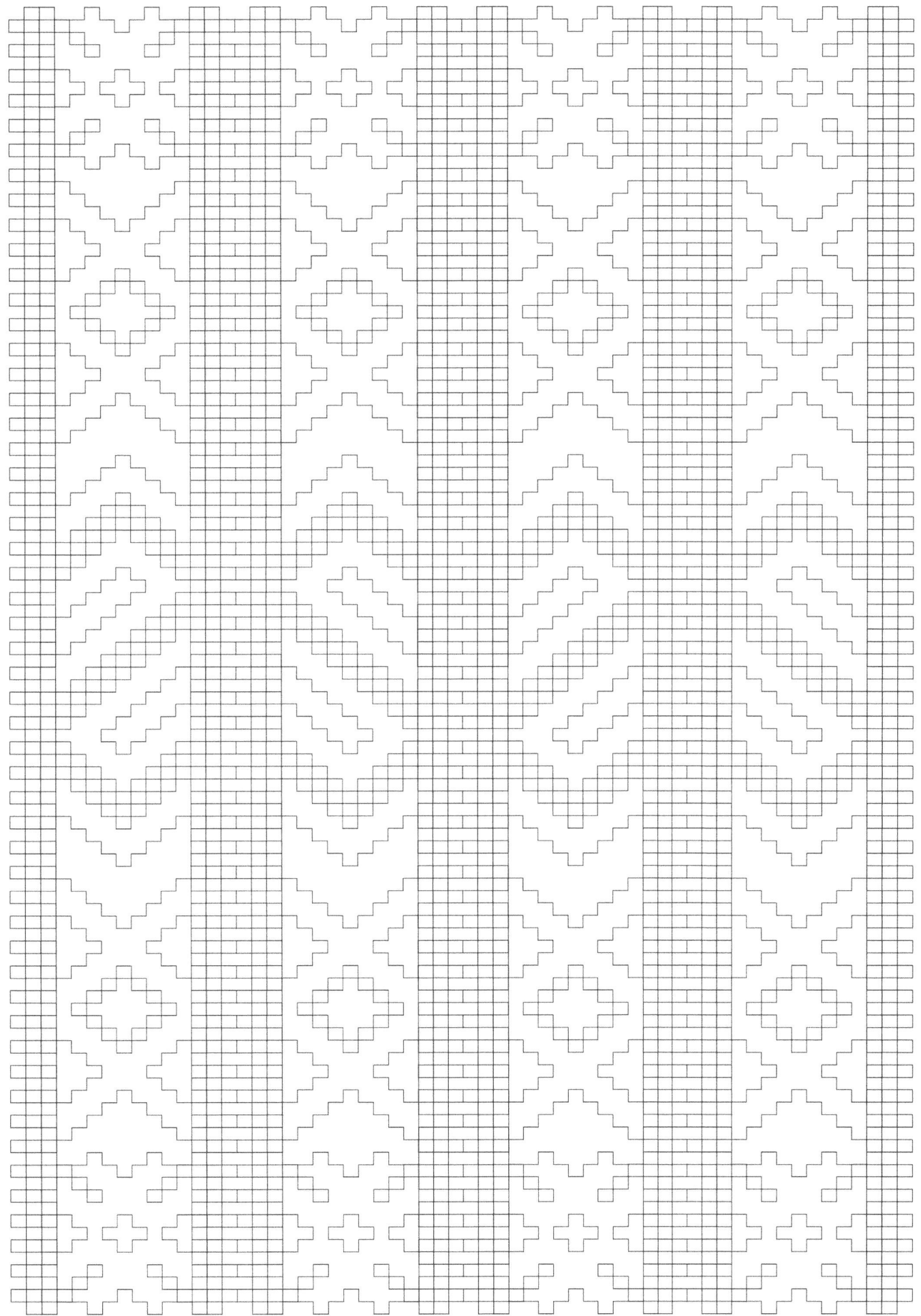

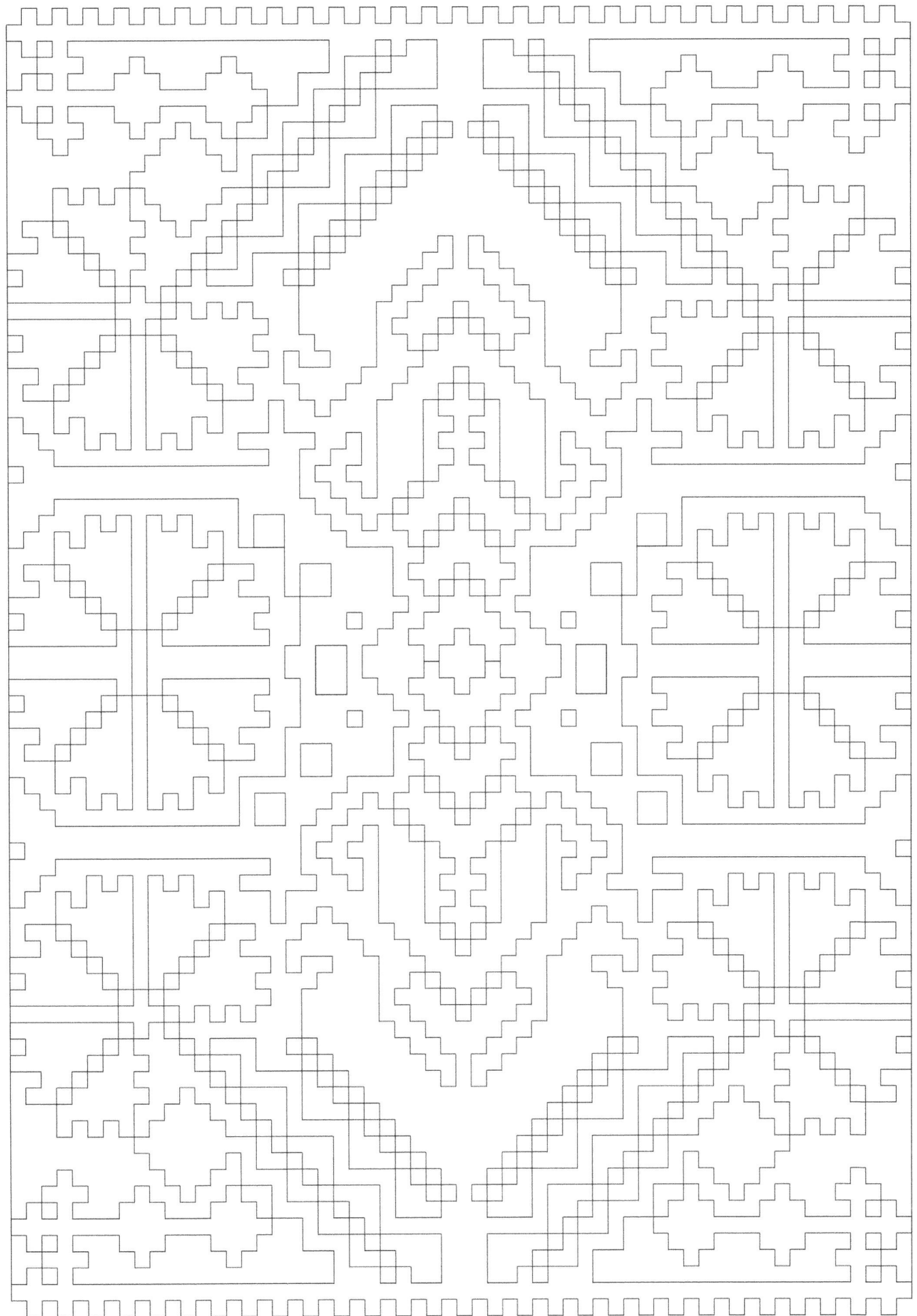

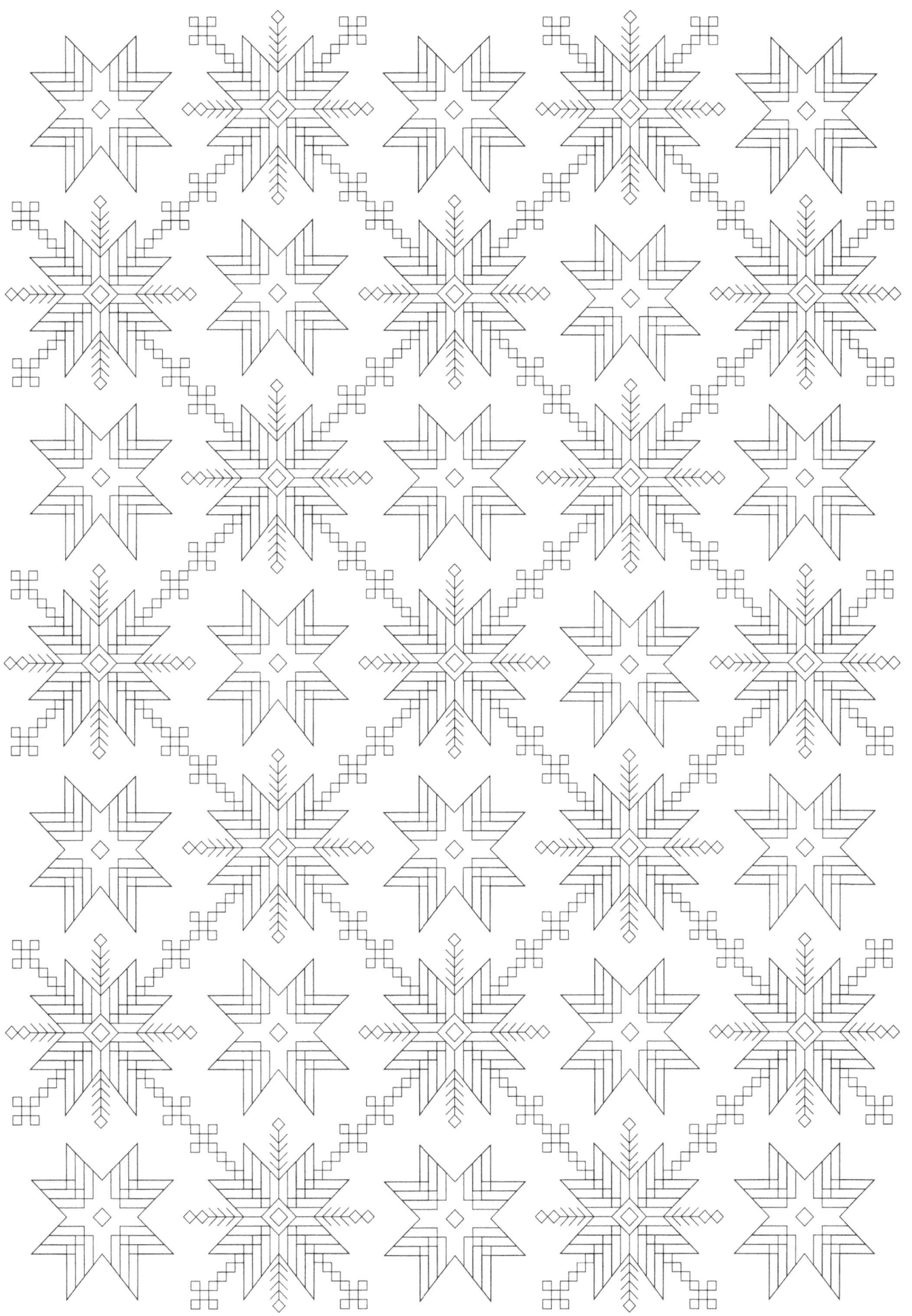

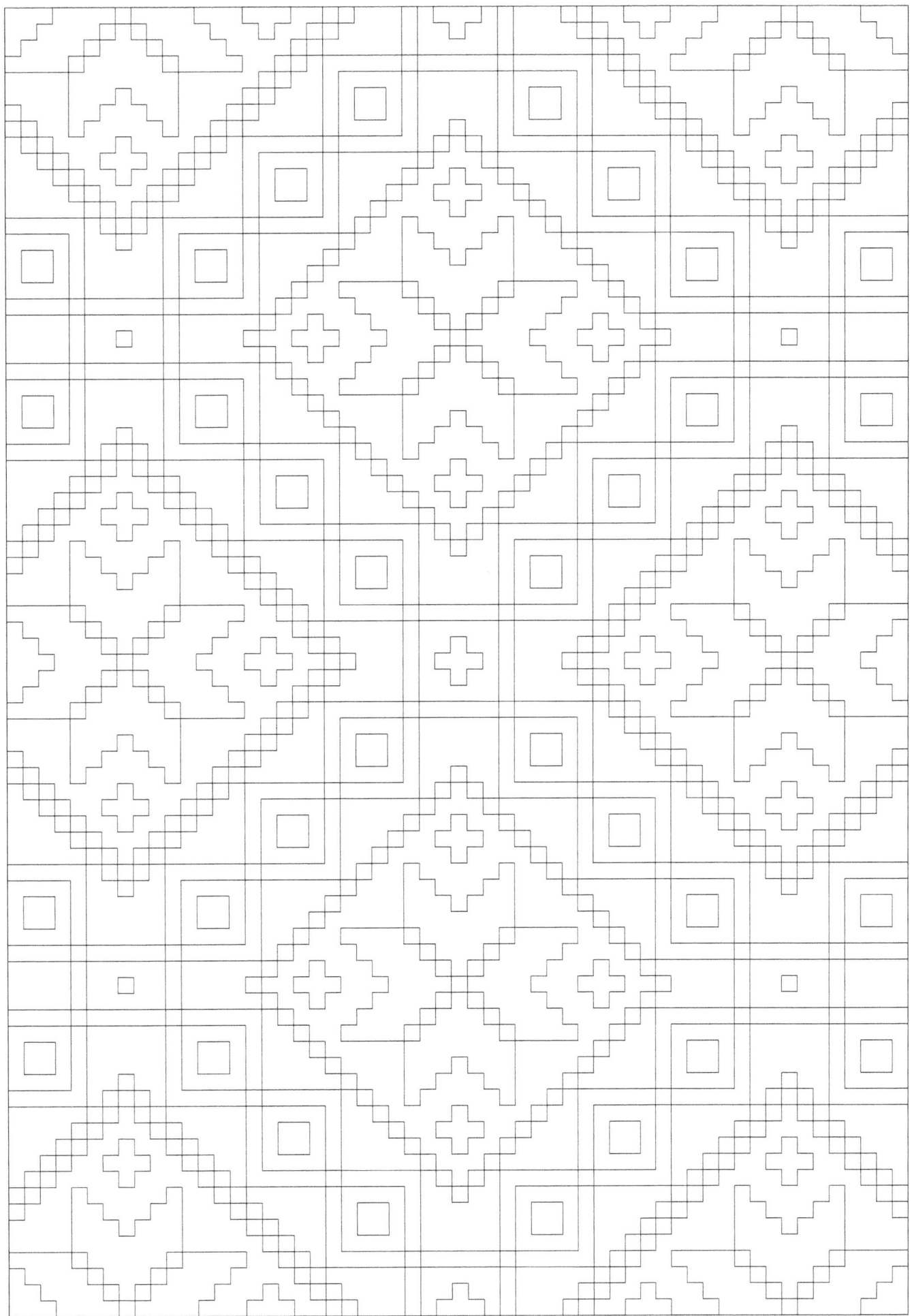

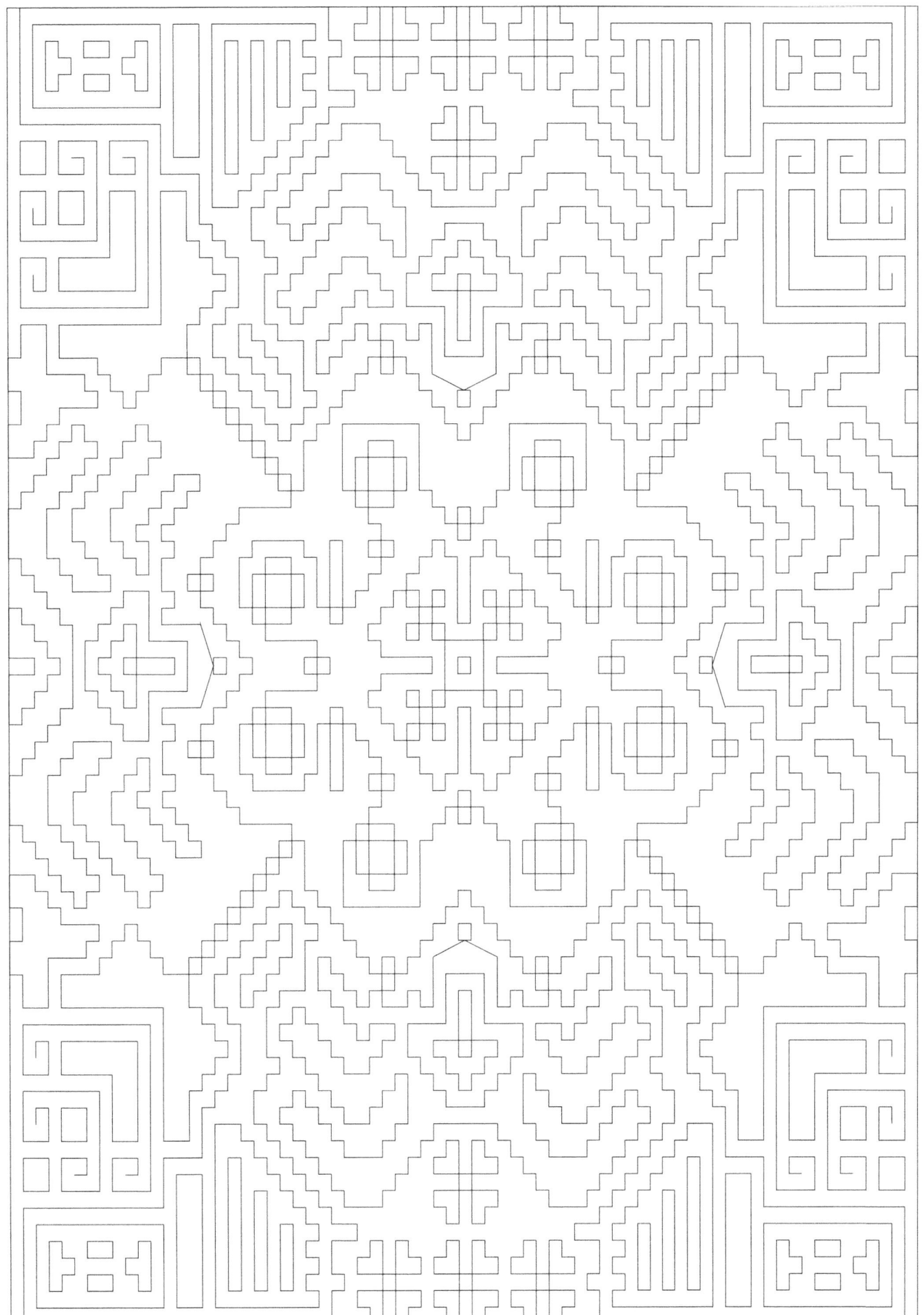

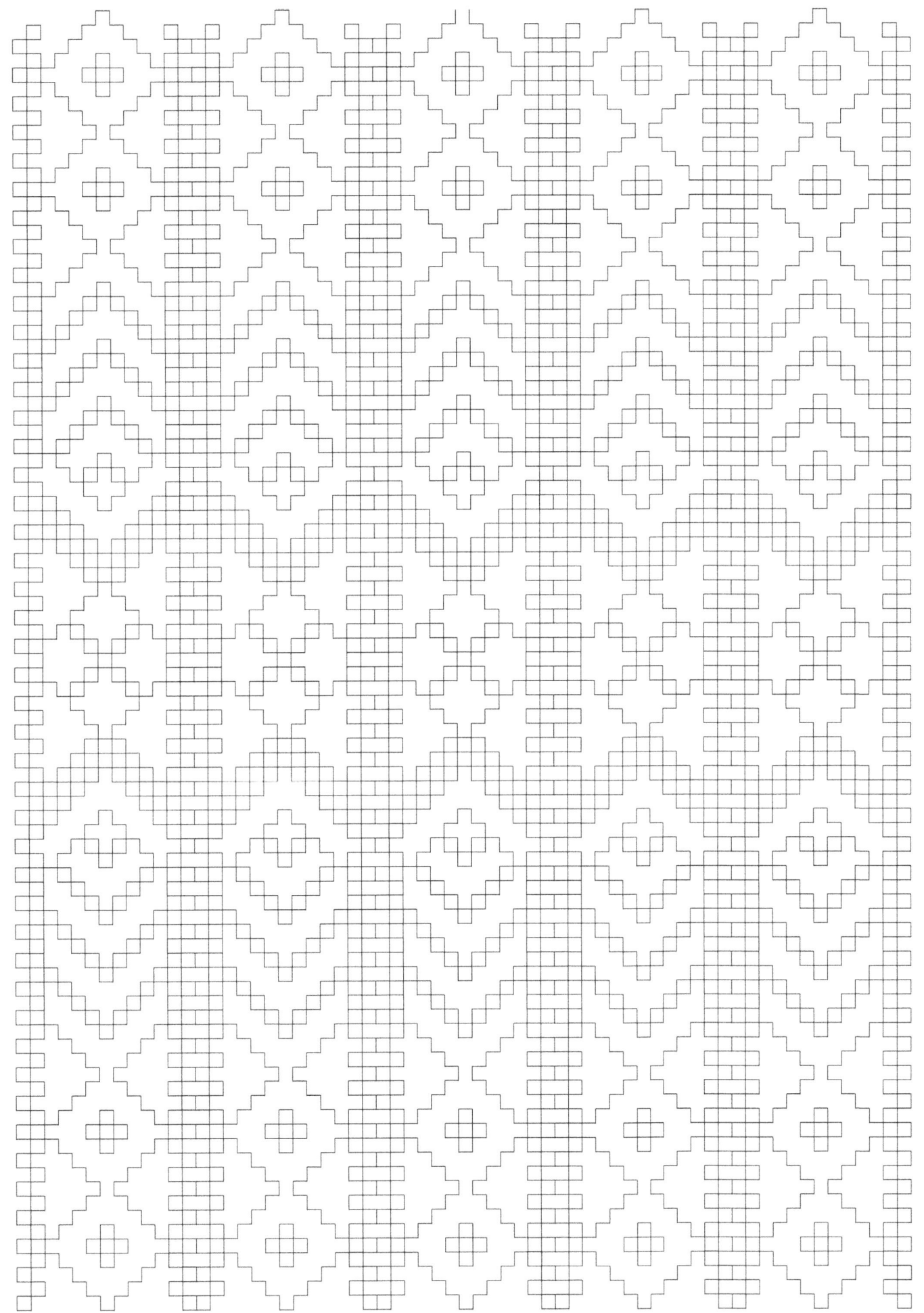

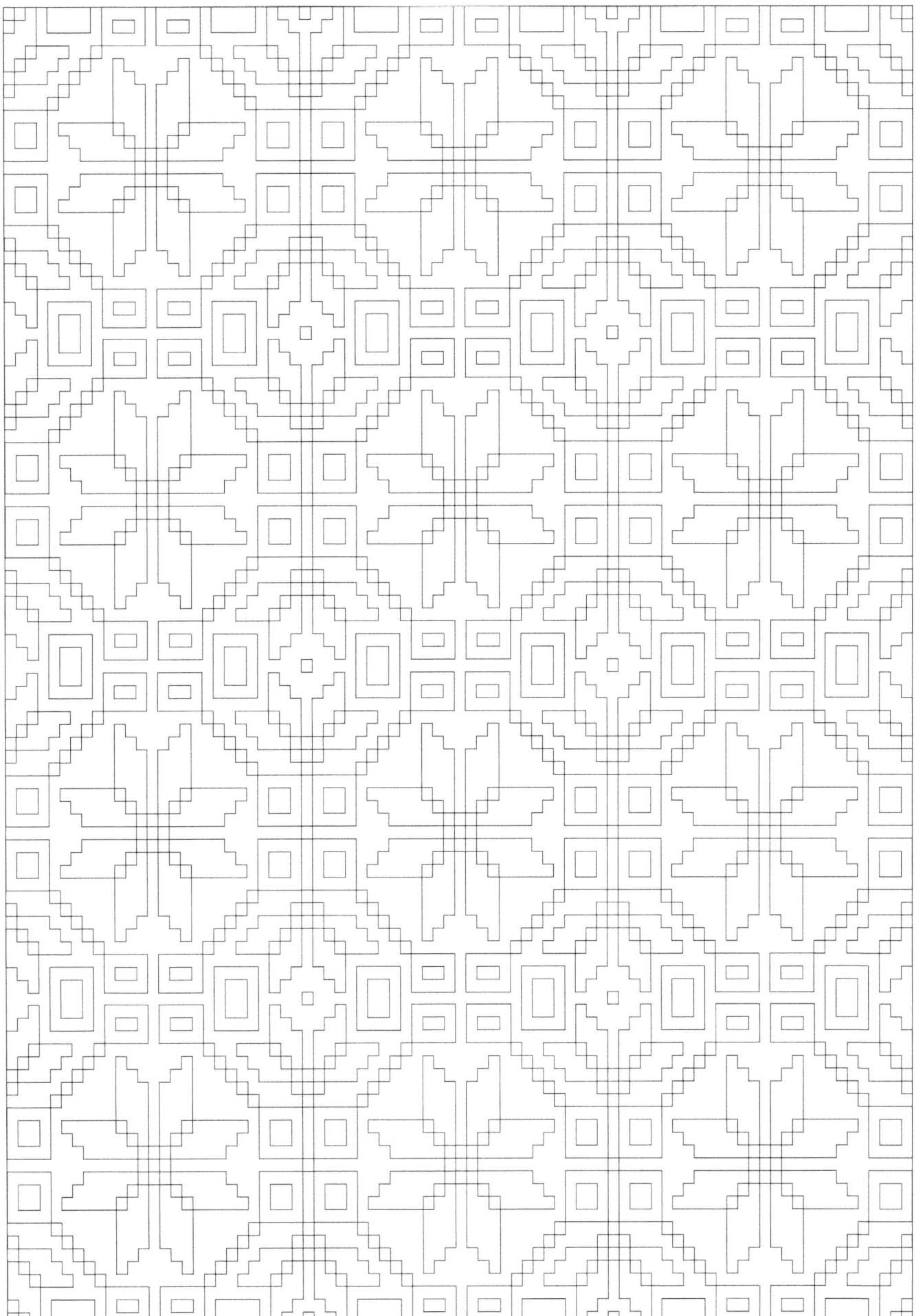

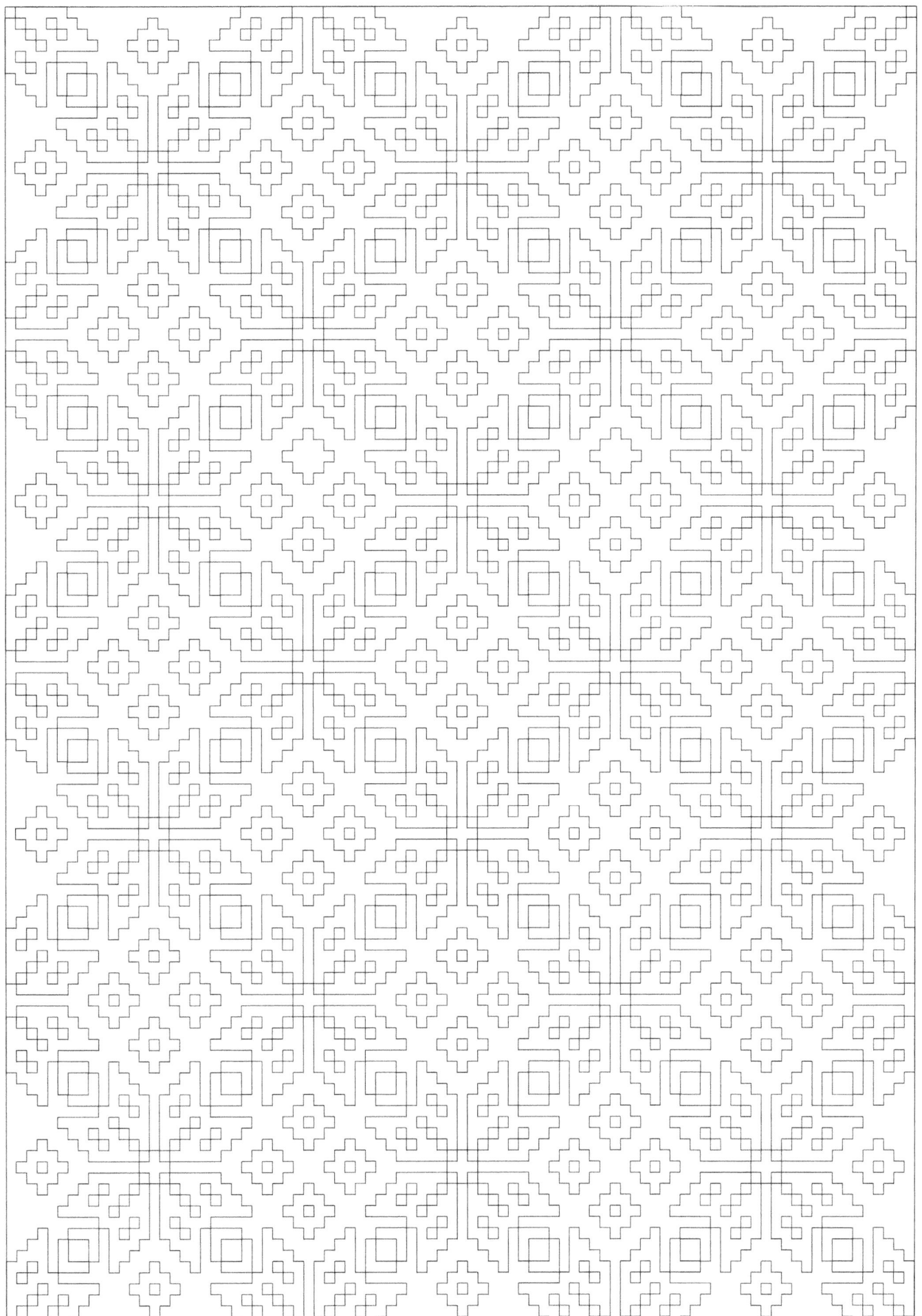

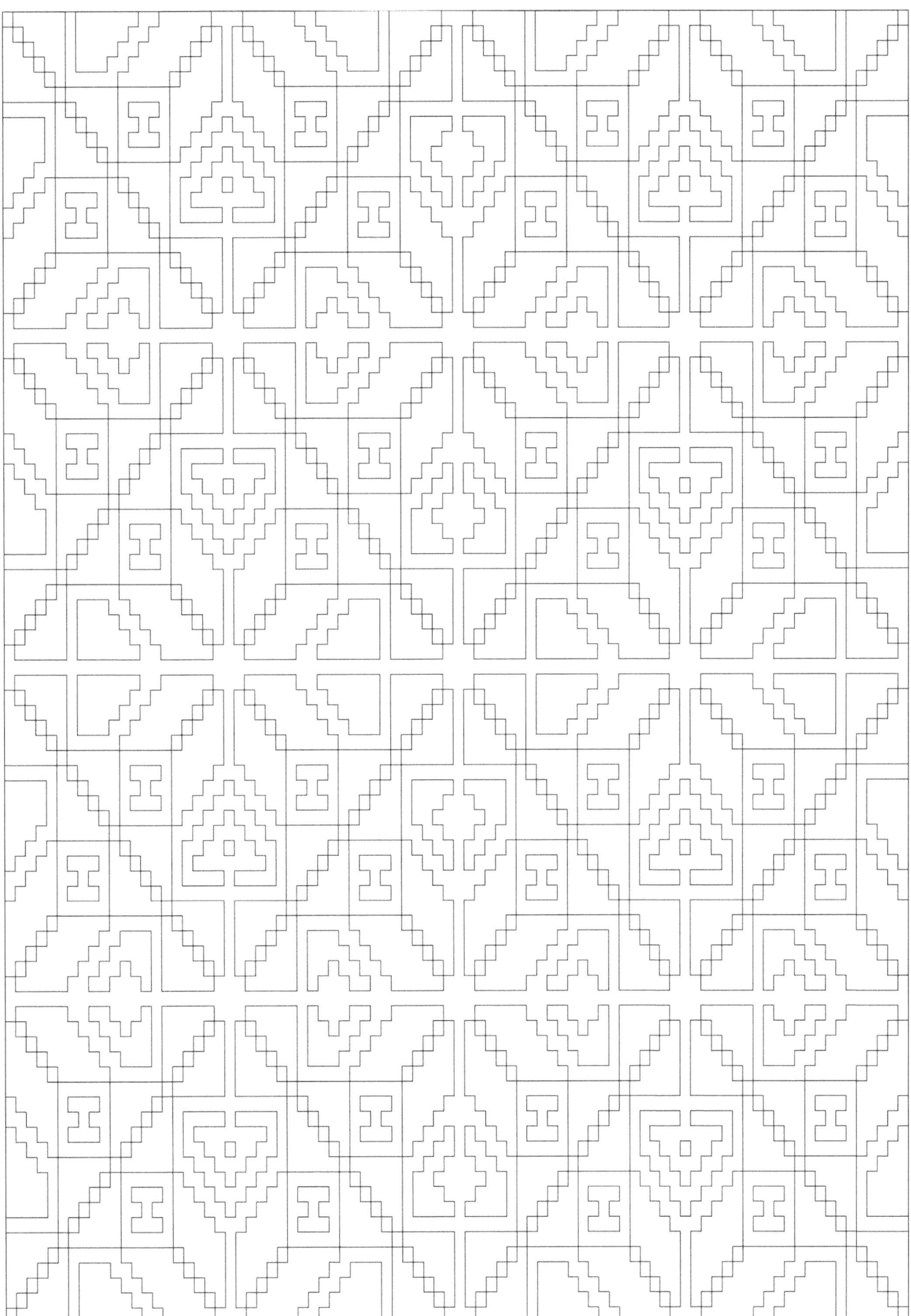

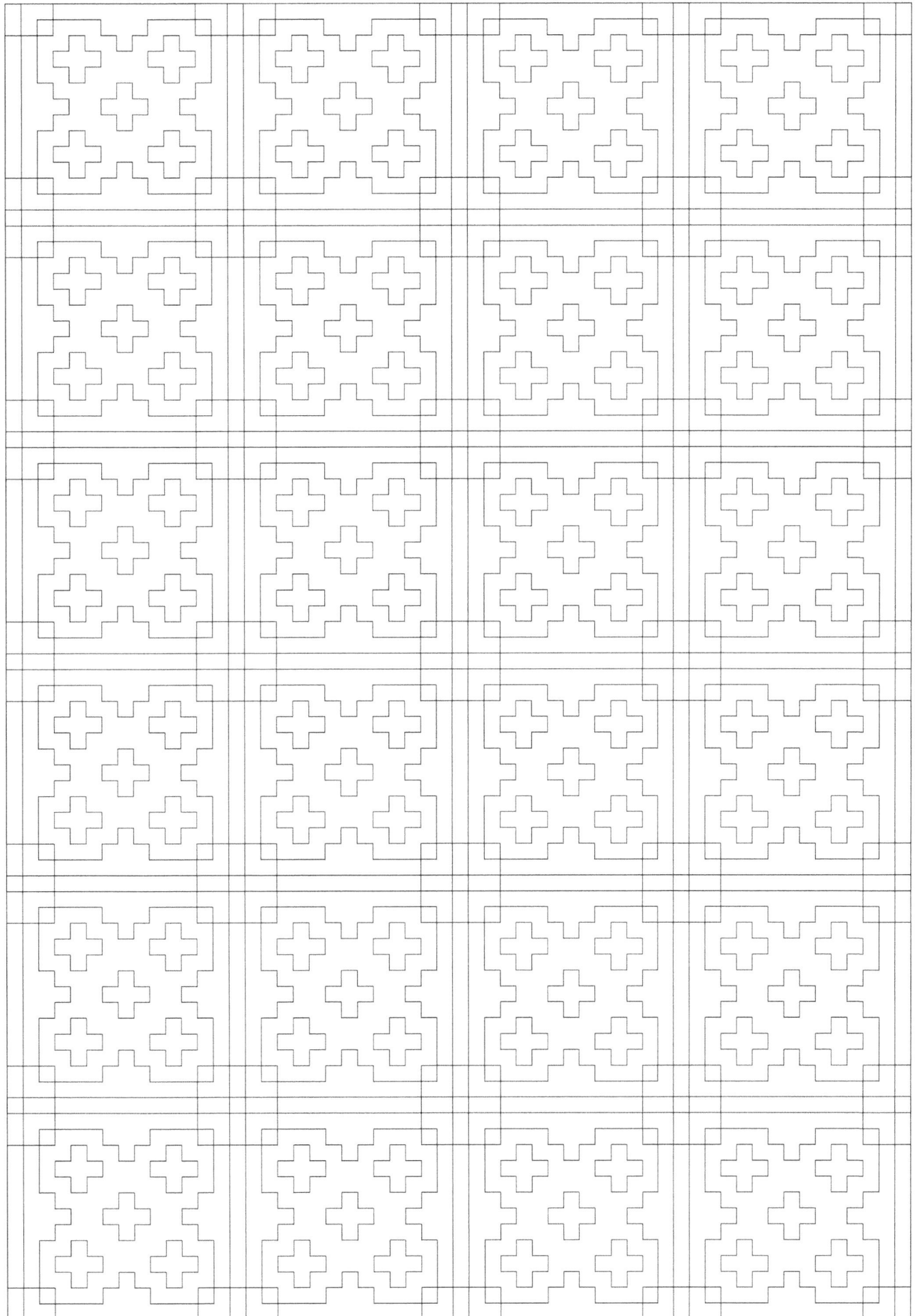

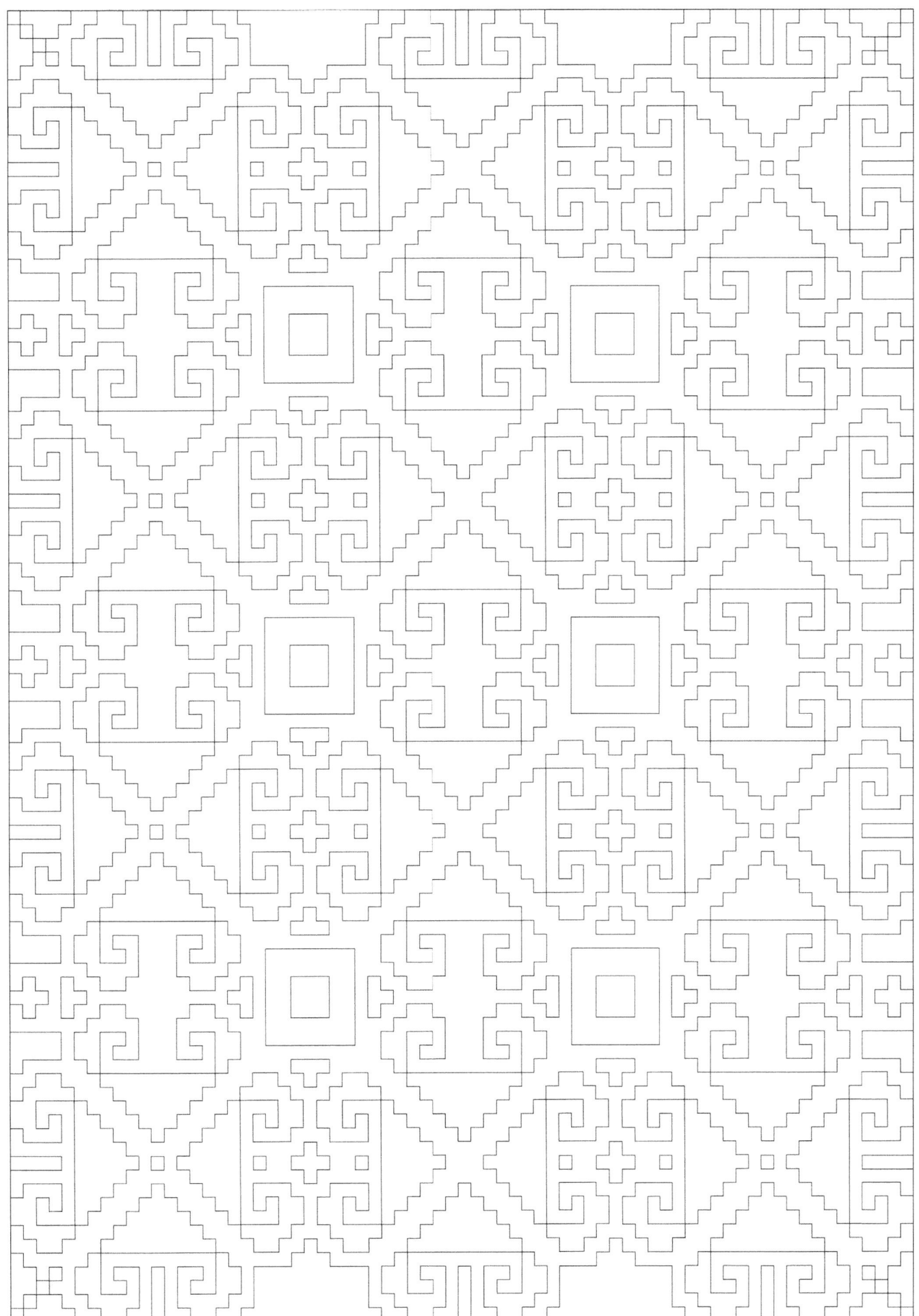

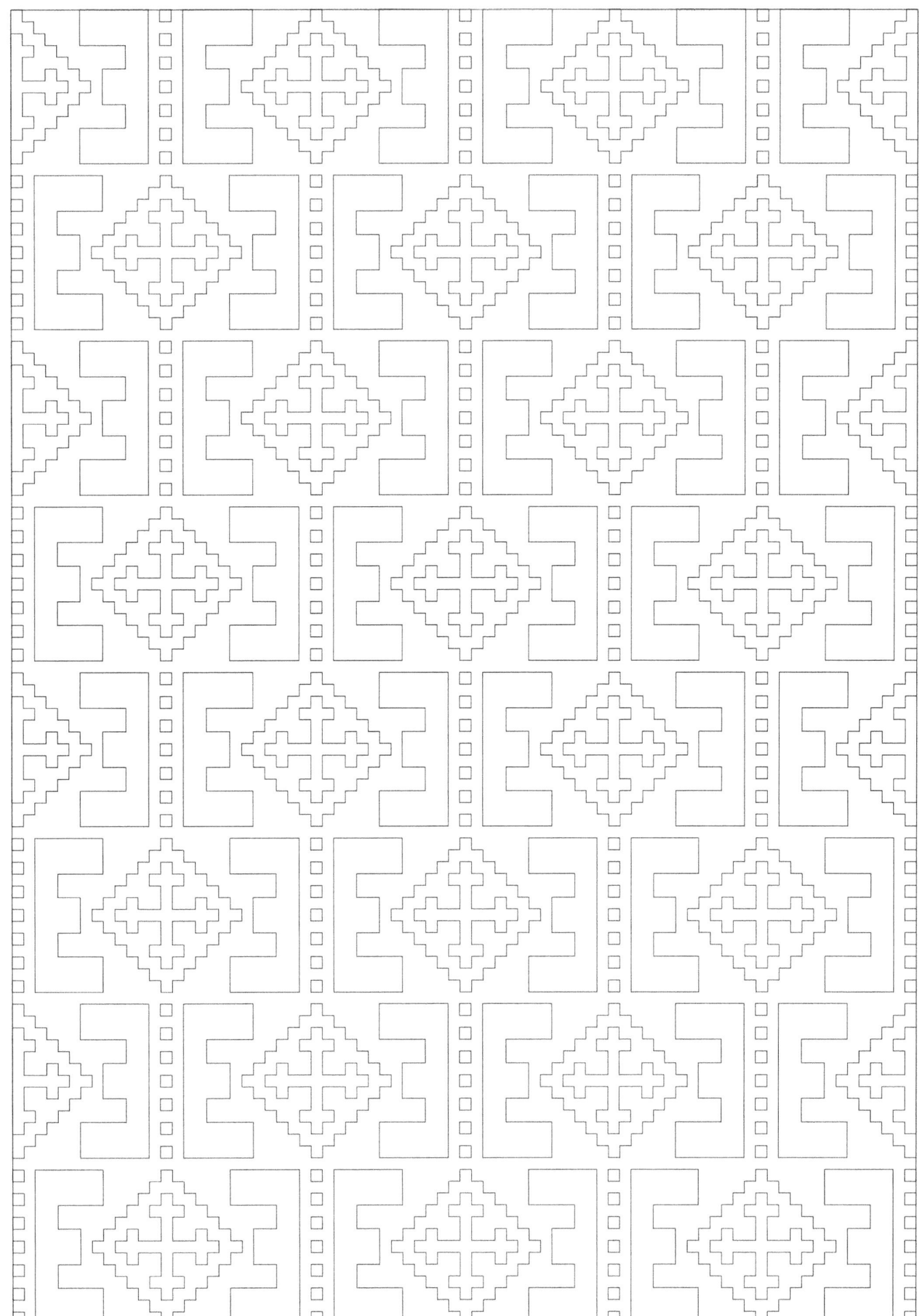

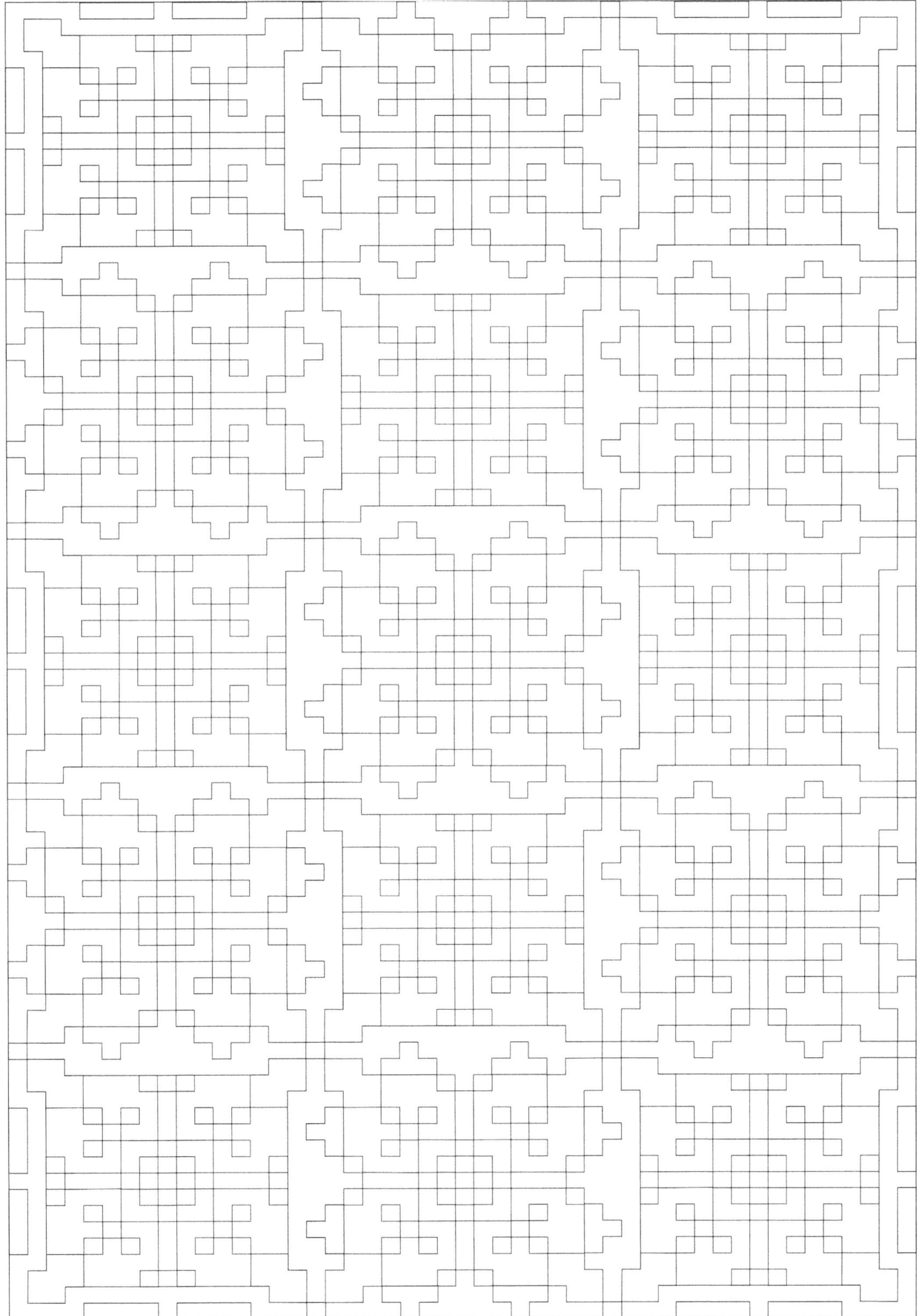

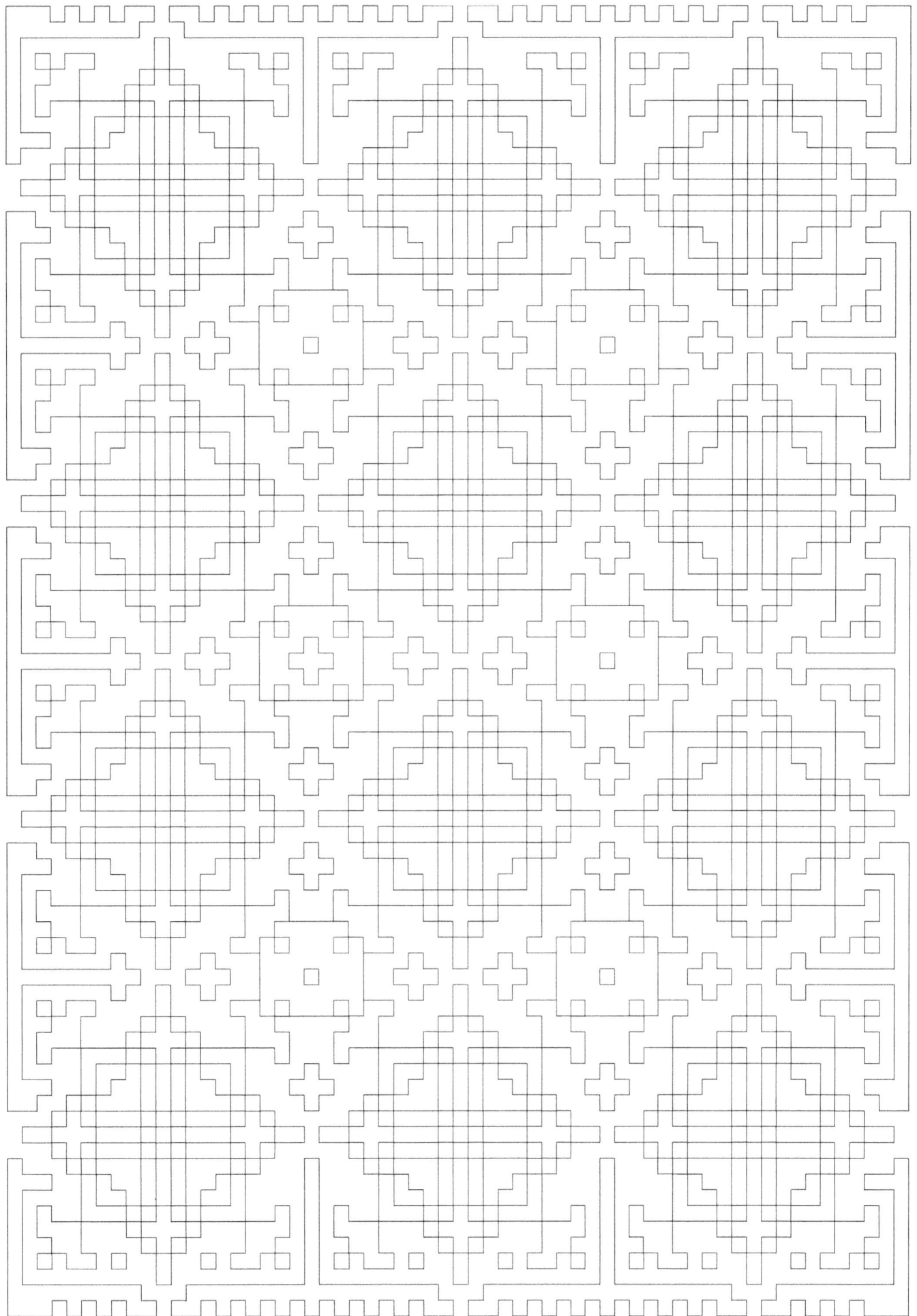

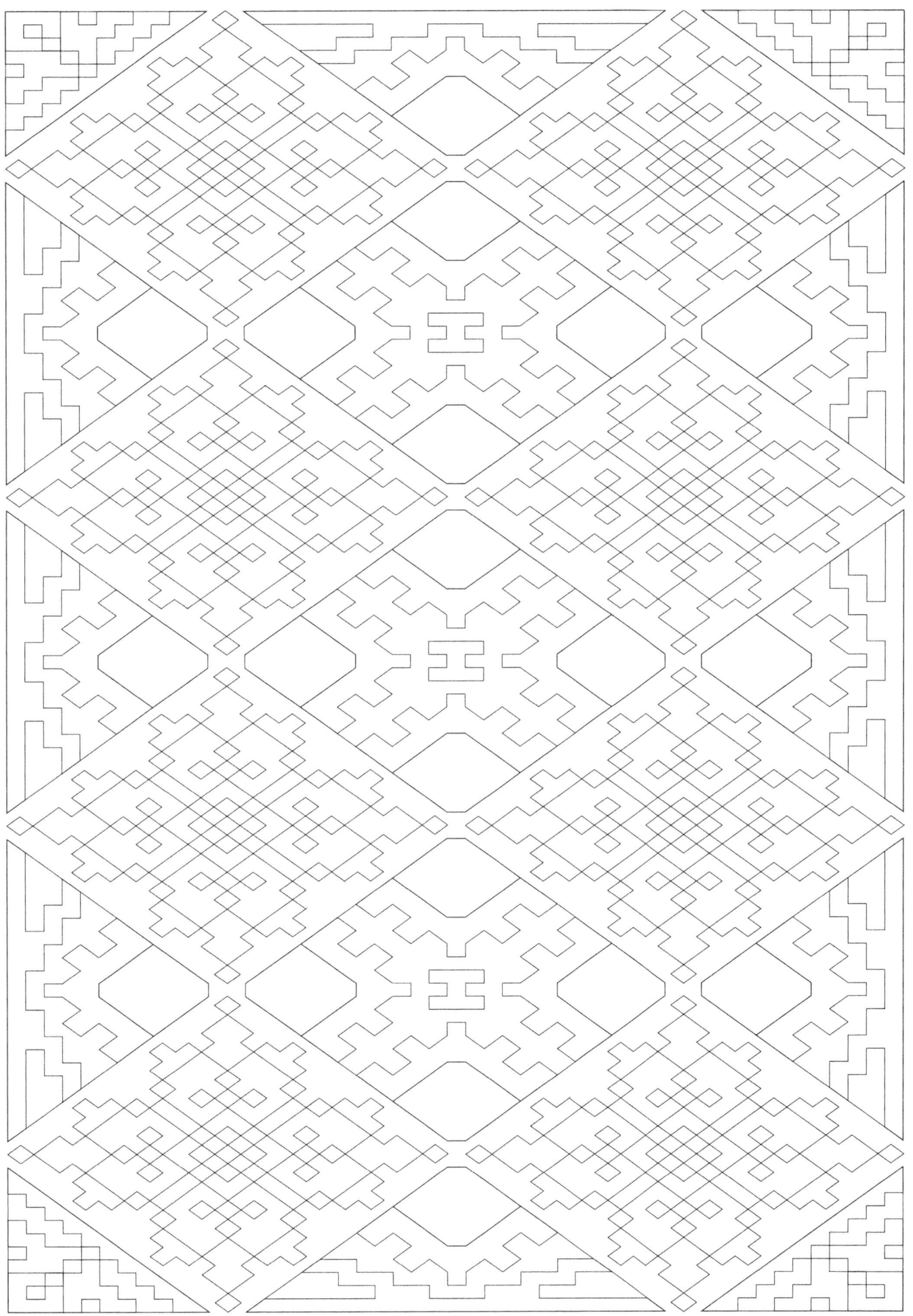

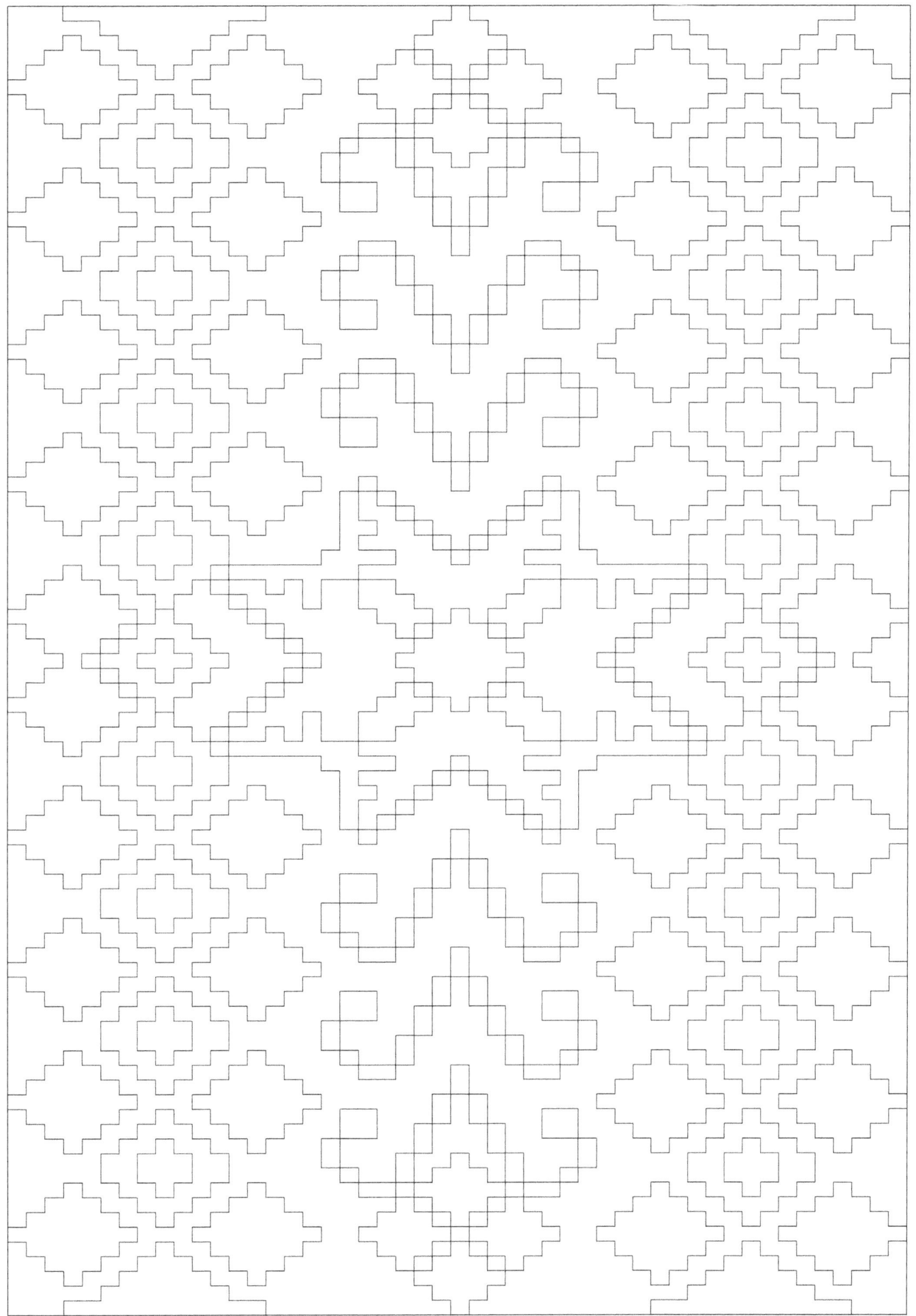

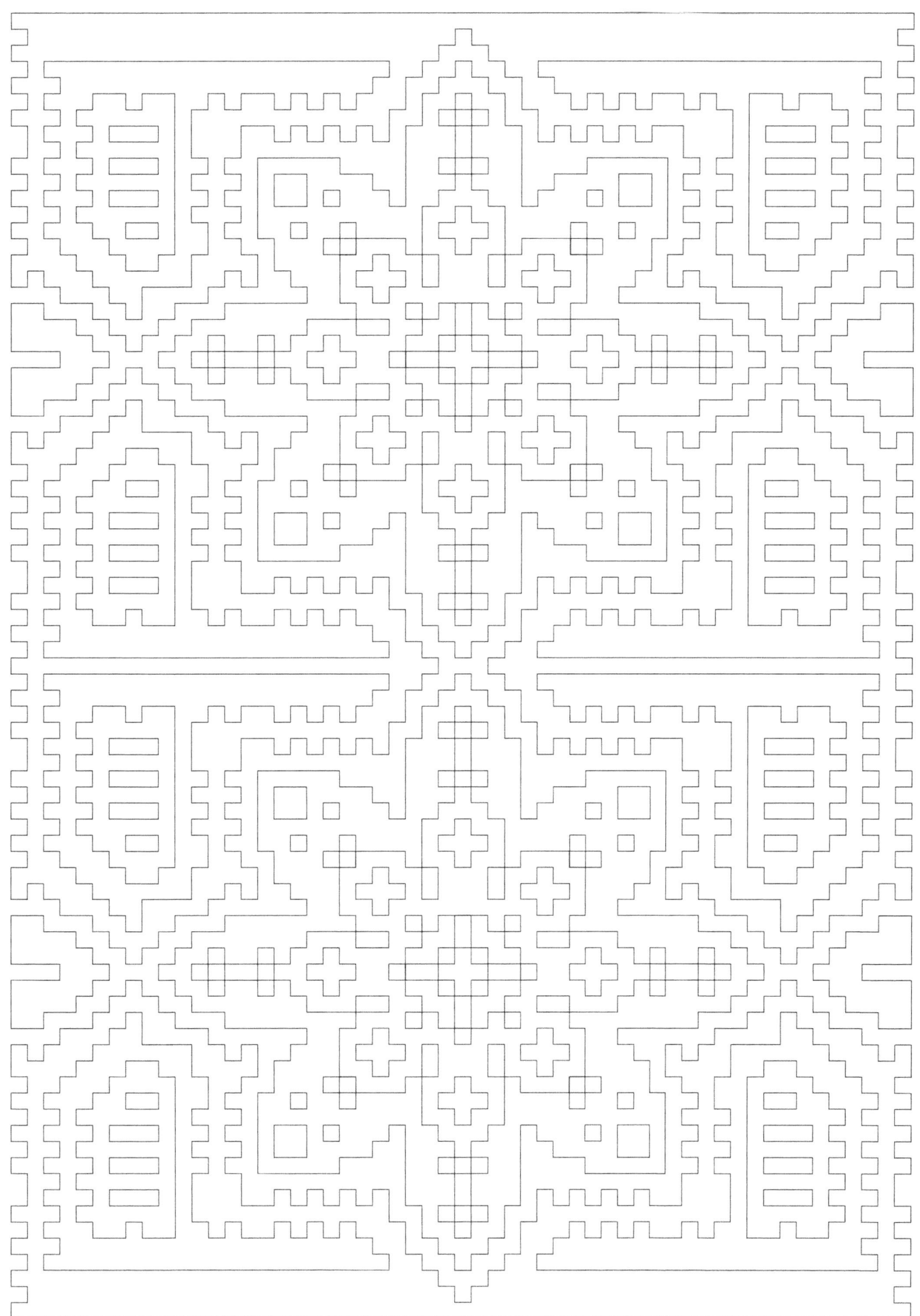

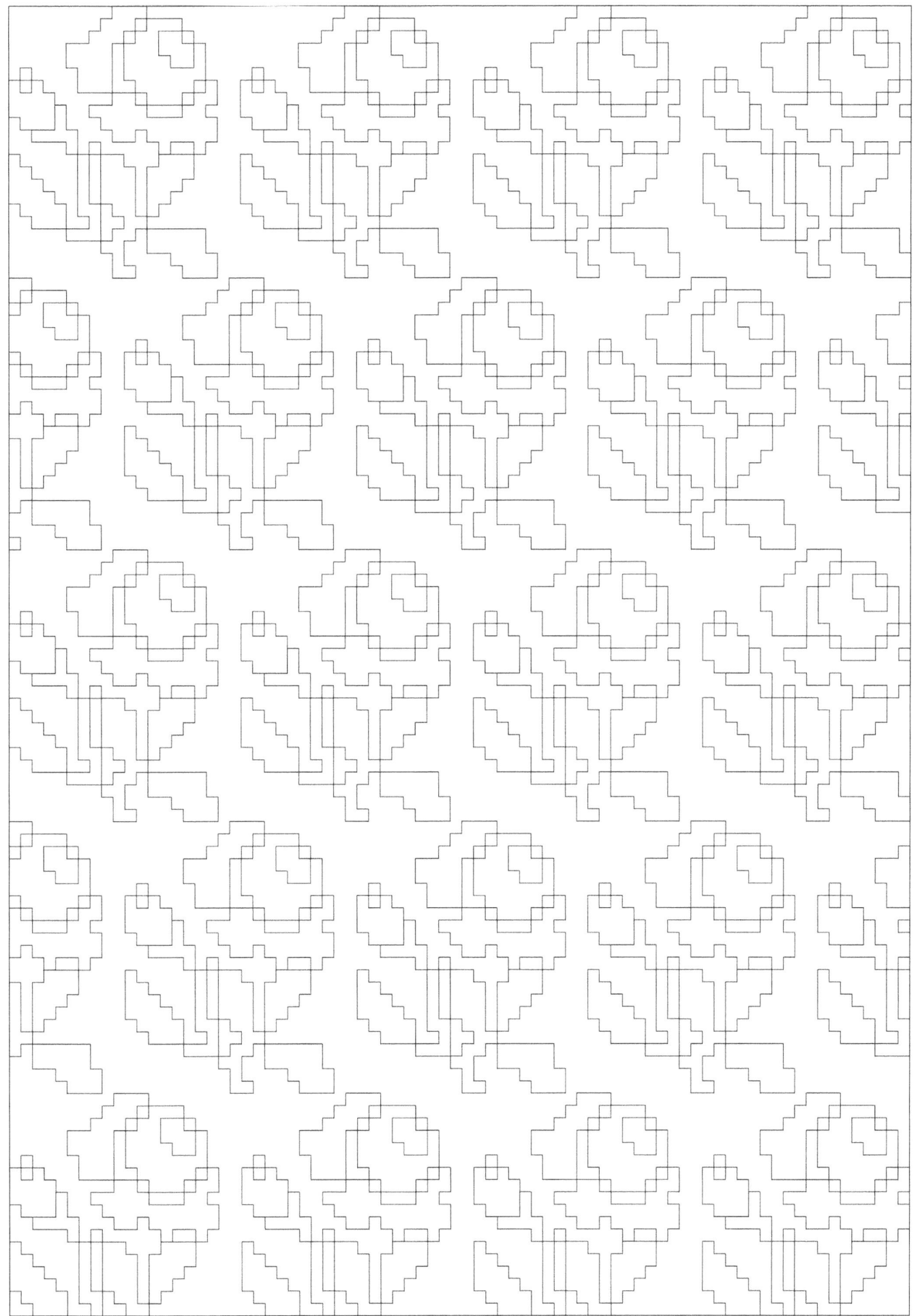

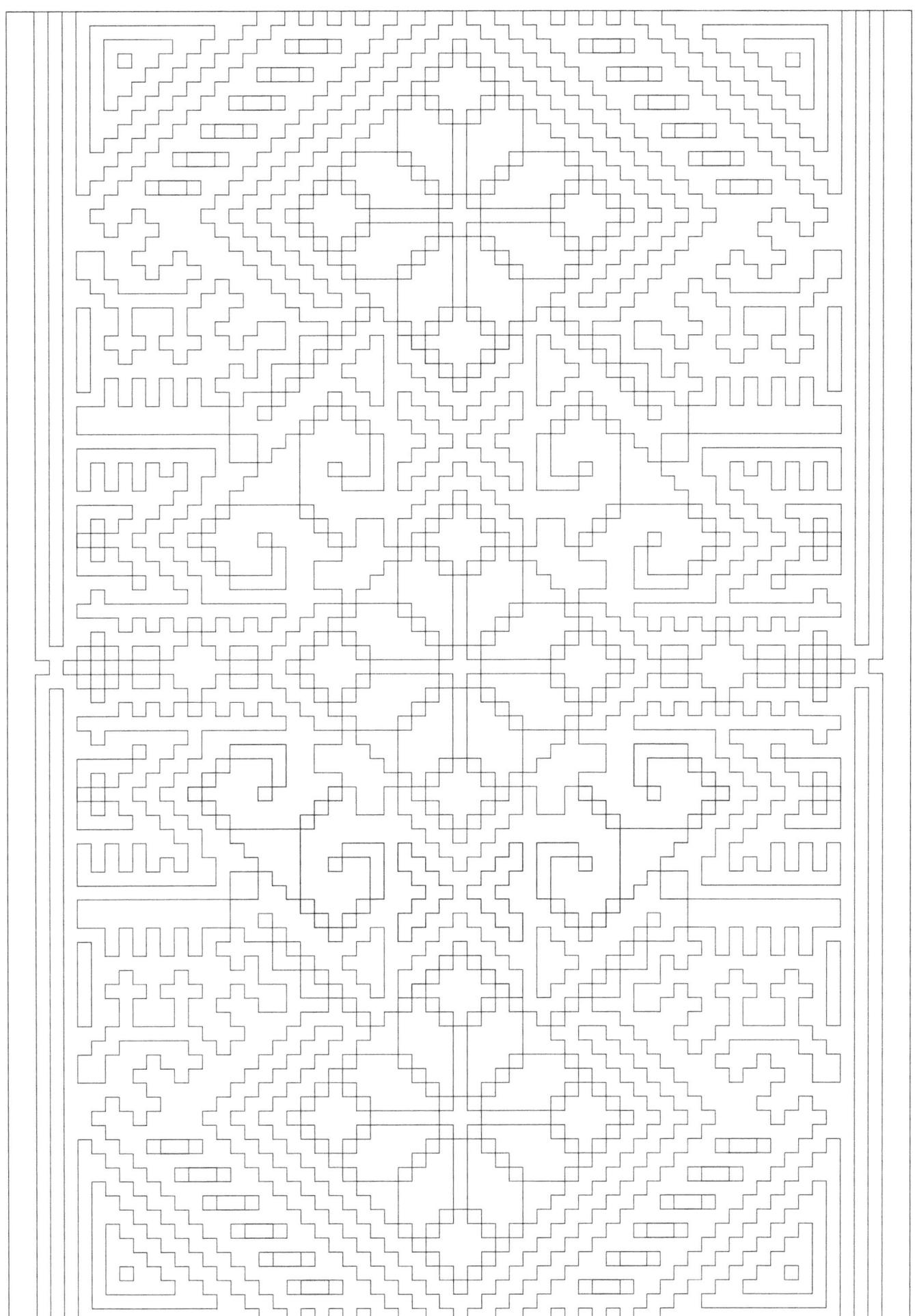

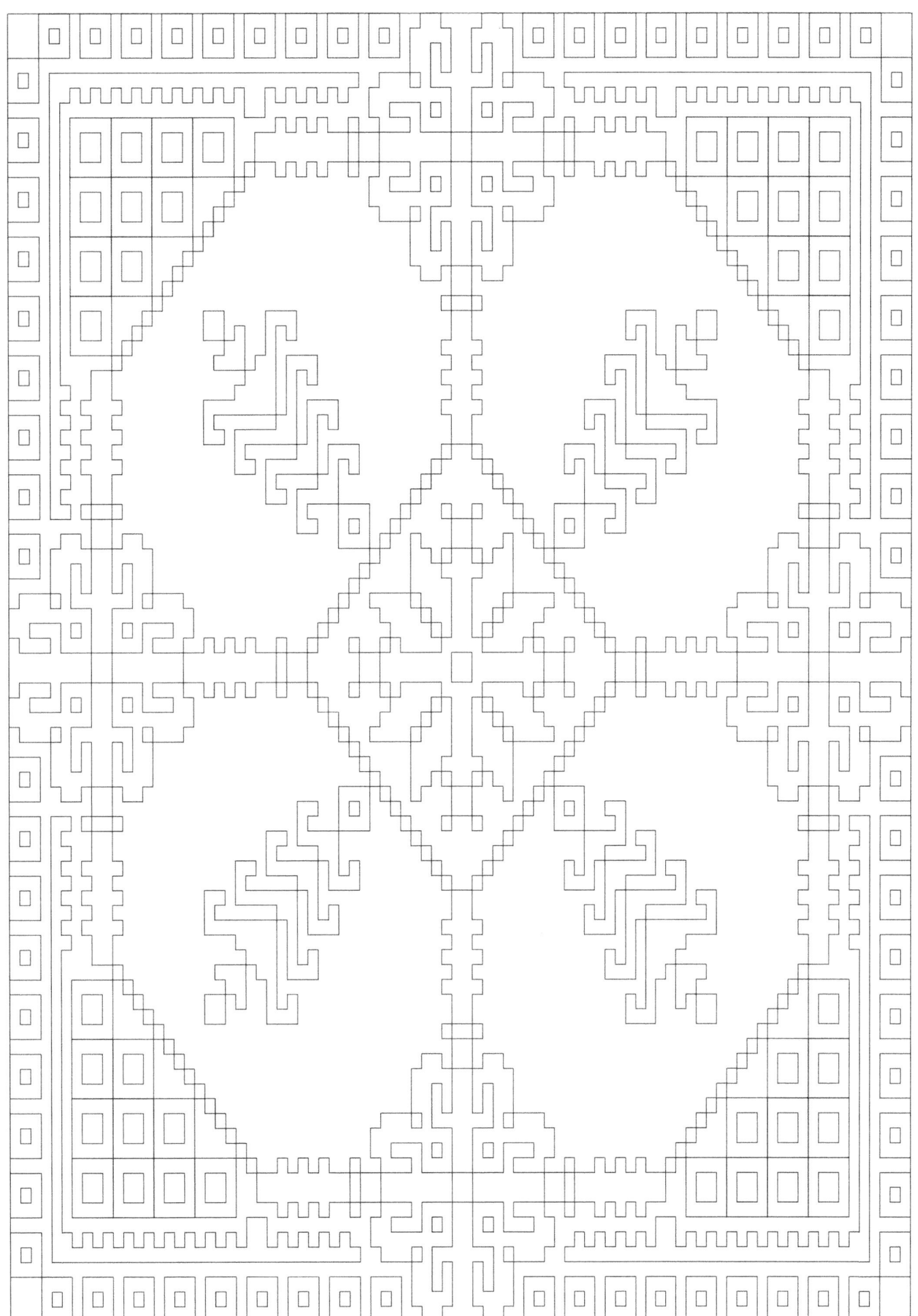

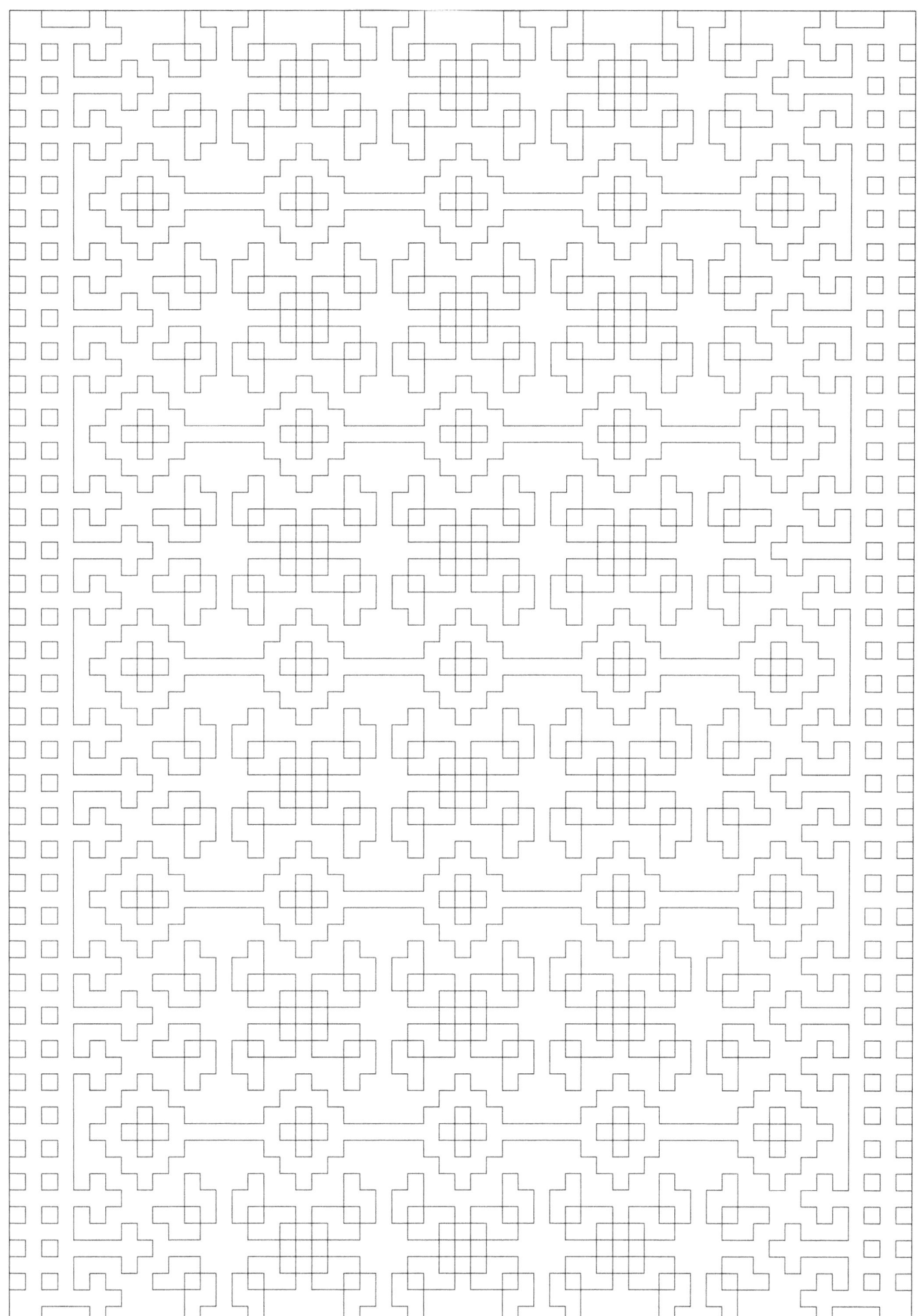

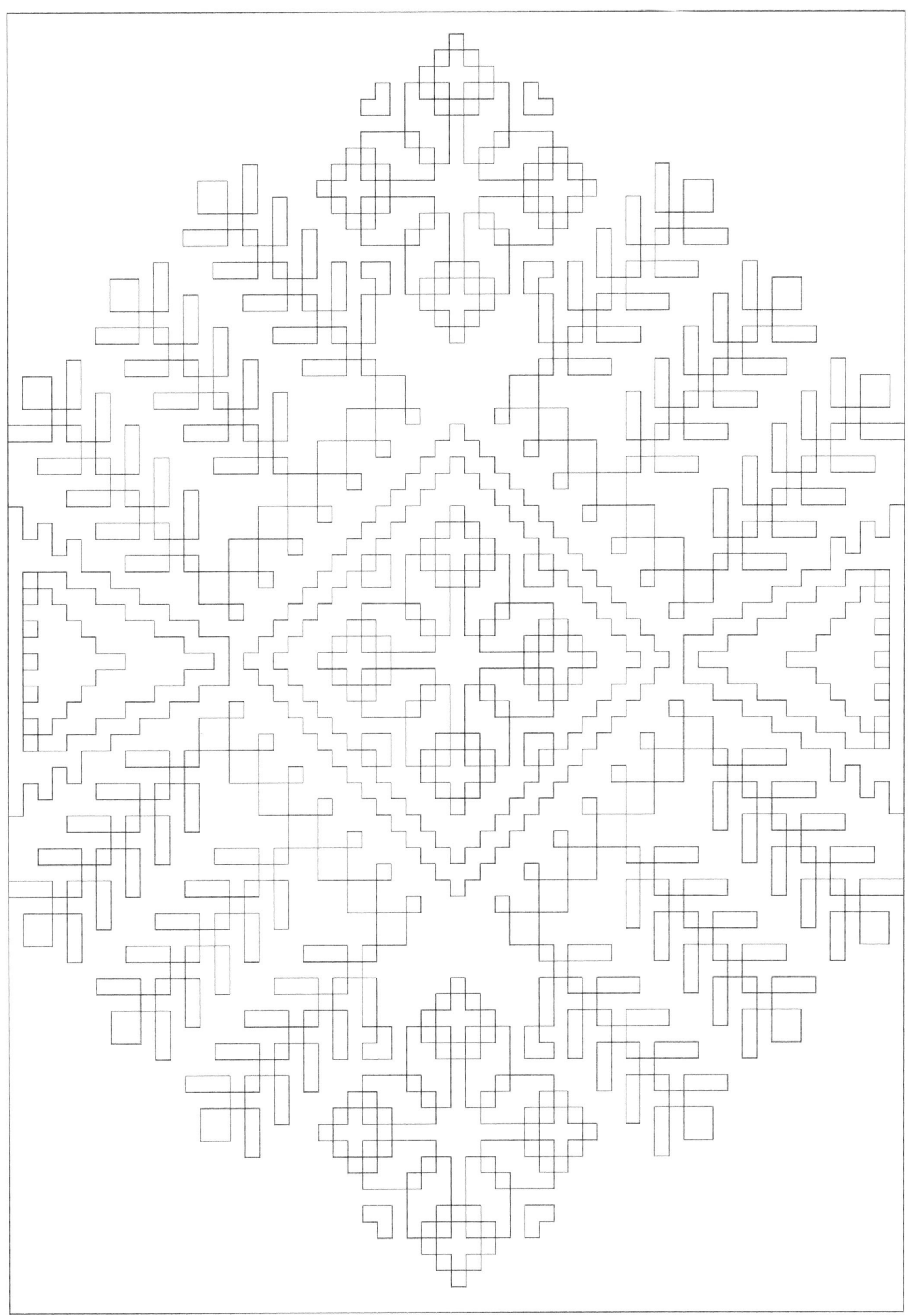

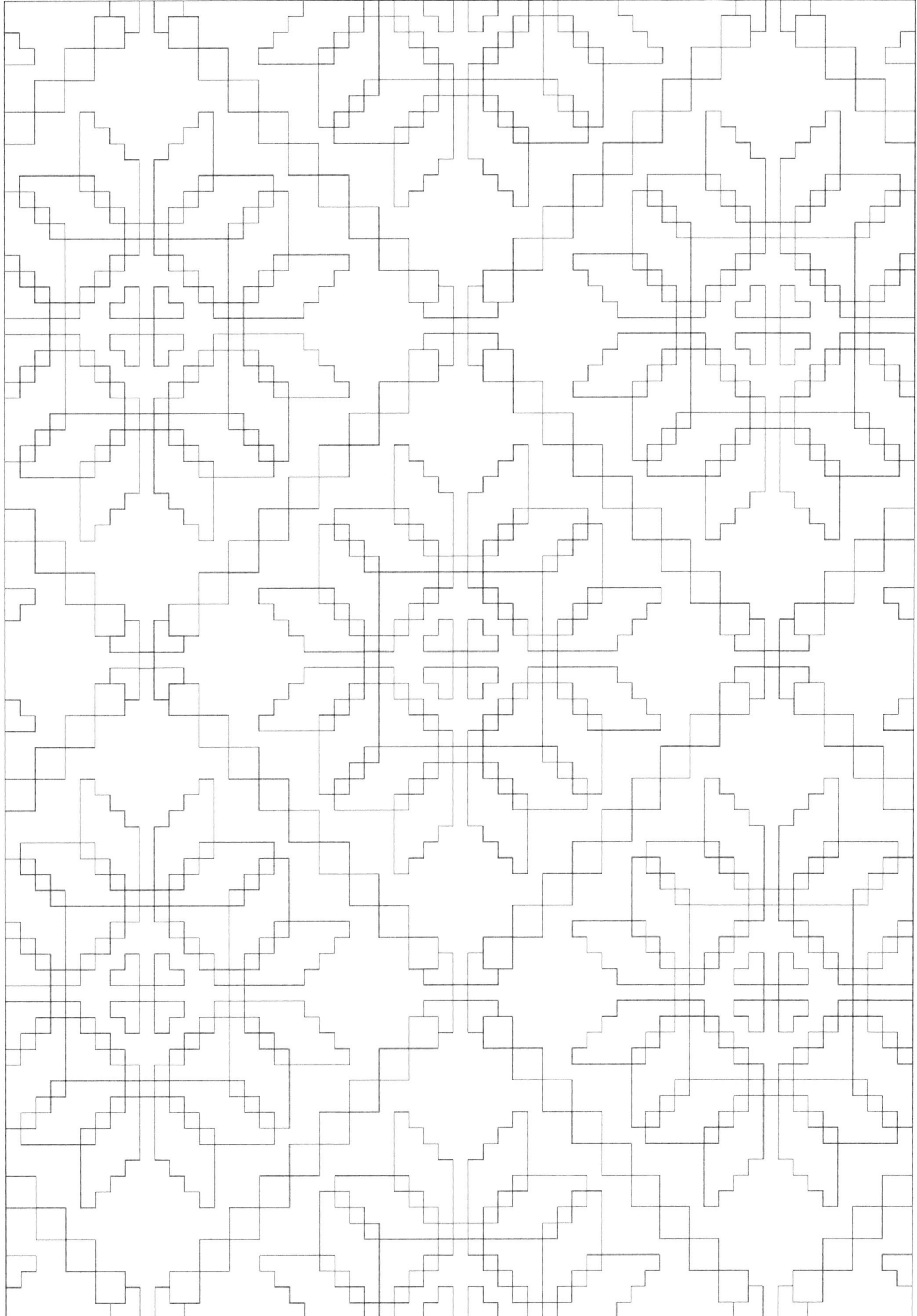

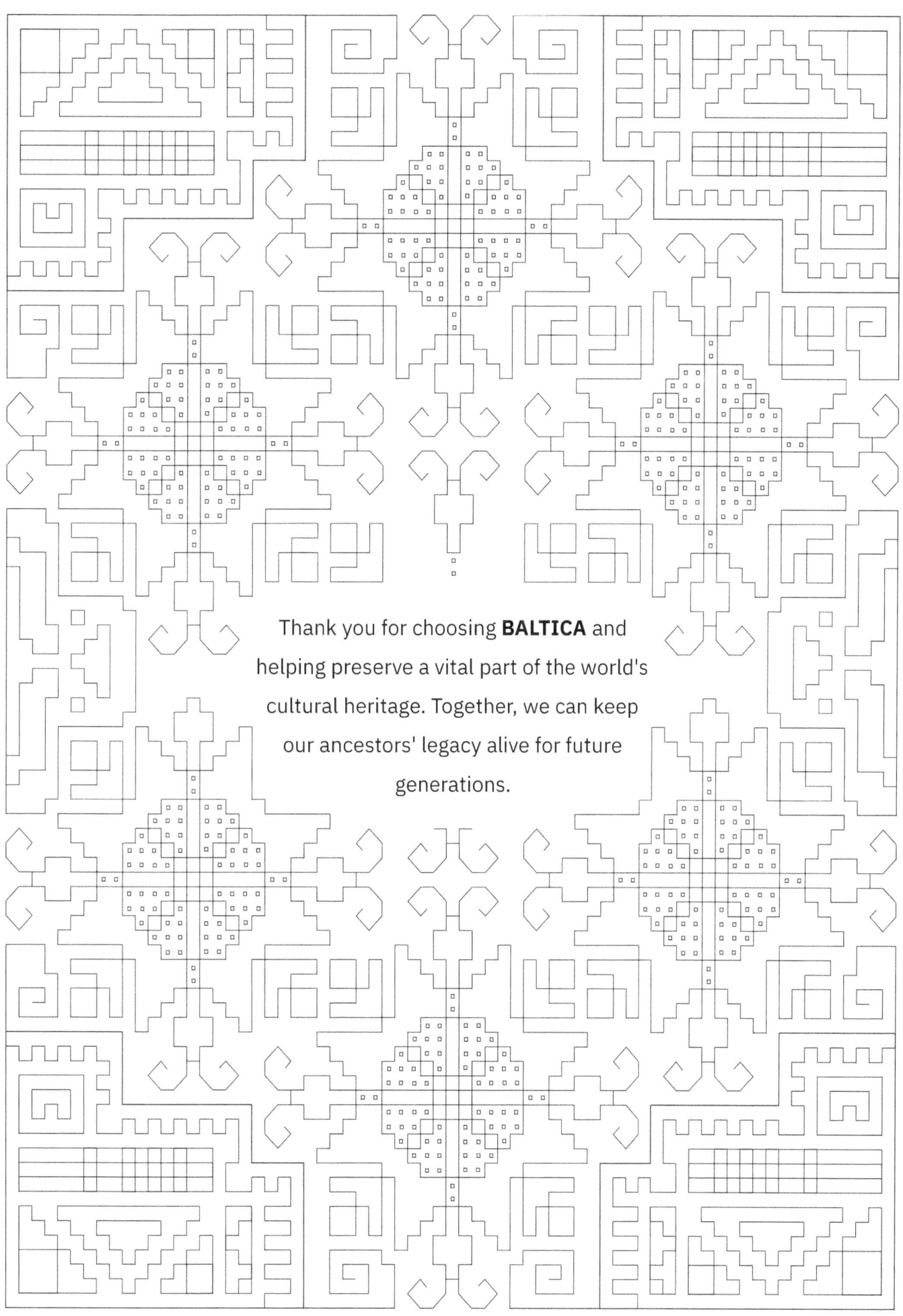

Thank you for choosing **BALTICA** and helping preserve a vital part of the world's cultural heritage. Together, we can keep our ancestors' legacy alive for future generations.

www.ingramcontent.com/pod-product-compliance
Lightning Source LLC
Chambersburg PA
CBHW081249180526
45170CB00007B/2353